BARRON'S ART HANDBOOKS

THE NUDE

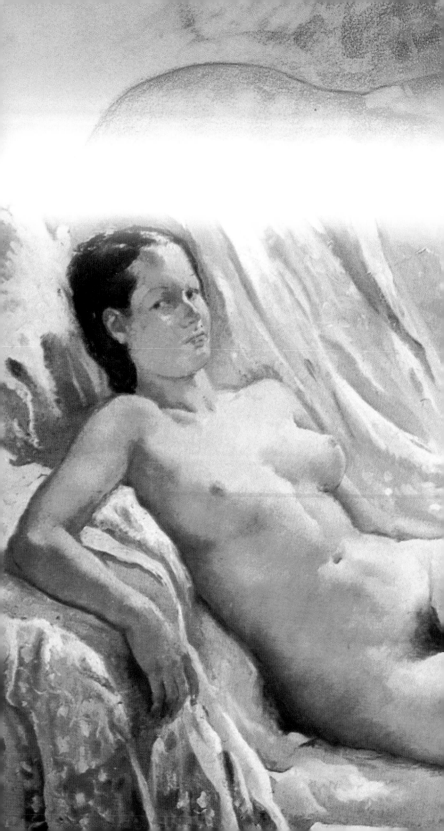

THE NUDE

BARRON'S

CONTENTS

5

CONTENTS

MODELS OF ANTIQUITY

Most aspects of today's nude date to ancient Greek culture. The Greeks were the precursors of all Western culture, but the one area they were most influential in was the plastic arts. In fact, it could be said that the nude was a Greek invention, which was then further elaborated and disseminated throughout Europe by the Romans.

The Model of Western Art

The remarkable evolution of Greek art derived from eastern and Egyptian influences (around the year 600 B.C.), which developed a number of figurative styles that culminated in the magnificent art of Classical Greece (around 400 B.C.). This marked the advent of a new set of standards for architecture, sculpture, and painting that was to revolutionize Western art.

The rapid development of Greek art extends from the Archaic (from the eighth century to 480 B.C.) to the Classical

Piombino Apollo. *Bronze of the second half of the fifth century B.C. Louvre Museum, Paris. This sculpture is a fine example of the transition from the Archaic form, hieratic and barely articulated, to the naturalism of the Classical period.*

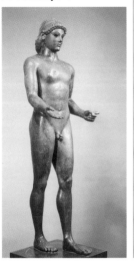

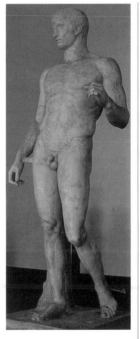

Doryphorous. *Roman copy in marble of the original by Polyclitus. National Archaeological Museum, Naples (Italy). This sculpture is accepted as the canon of the Greek nude of the Classical period.*

(480–323 B.C.). The course of the composition of the Greek figure can be followed step by step from its origin in Archaic sculpture. At the beginning of the Classical period, the Archaic structure of the figure was maintained: frontality, symmetry, and one foot forward. Nonetheless, later on, the figures appear more at ease, with the body's weight resting on one foot, the waist raised, the body slightly bent; "flesh and blood" had come of age.

The Canon of Proportions

In 440 B.C., at the height of the Archaic period, the sculptor Polyclitus laid down the first canon of human proportions in his statue the Doryphorous. Polyclitus wrote a treatise about his invention entitled *Canon*, "the rule" or "the formula." Polyclitus established a height of seven and a half heads for the figure,

Praxiteles, Hermes and Child. *Fourth century B.C. Archaeological Museum of Olympia, Greece. A state prior to the canon established by Polyclitus in which the human form acquires more graceful and stylized proportions.*

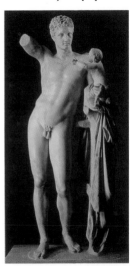

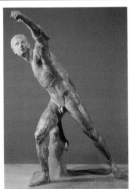

Warrior in combat, known as the Borghese Gladiator. Marble from the first century, B.C. The Louvre, Paris. This is a sculpture from the last phase of the Greek Classical period, called the Hellenistic. The nude had acquired maximum mobility and came to symbolize energy.

a standard that produced a robust and strapping model. But Polyclitus' standard also alludes to the relationships between the different parts of the body: between the fingers and the hand, between the hand and the forearm, between this and the upper arm, and so on, and everything based on anatomical reality of the human body. These relationships remain relevant to this day in human figure drawing instruction in art schools and academies. From Polyclitus onward, the human figure moves more naturally and adopts particularly harmonious poses: the contraposition of the shoulders and the hips.

Around the year 320, Lysppius's sculpture, *Apoxyomenos*, introduced a new scheme of proportions, more slender, with a height of eight heads. Lysppius, a celebrated sculptor, was Alexander the Great's favorite artist, and his figures broke definitively with the frontal poses, turning his figures' shoulders in the opposite direction to which their hips were facing. With the arrival of the Hellenistic period (323 to 27 B.C.), the stature had obtained complete freedom of movement. These freedoms can be observed with great intensity in ceramic paintings. Carried away by their desire to attain elegance and slenderness, the painters normally applied the eight-head canon, but they often increased this to nine and sometimes more, demonstrating a perfect mastery of anatomy and movement.

Rome

From its beginnings, Roman art was a reflection of Greek art. It began in the sixth century B.C., in central Italy, where Etruscan art was manifested as a projection of Greek art, and was consolidated when Rome began to rule central Italy and later on made contact with the Greek cities of the south of the penin-sula. The treasures of Greek art were then transferred to Rome, and the Romans became enthusiastic collectors of artistic objects. So much so that Roman historians scorned all original artistic productions prior to the Classical period of Greek art; indeed, they affirmed that, after that great creative period, "art had been halted in its tracks." Therefore, artists were compelled to faithfully reproduce the great Greek achievements, and little else, given that Greek research into the representation of the human body, its muscles, and its movements appeared definitive. The most an artist could aspire to was to combine in a different form the perfect figures of the Greek legacy. Such combinations paved the way to the immense figurative repertory that many centuries later would inspire the artists of the Renaissance.

The Canon and Art Before Greece

Greek statues set a standard of proportions that has survived (with minor adjustments according to fashion and style) over the centuries. But this was not the only culture of Antiquity to determine a system of fixed proportions. Ancient Egyptian painters and sculptors used a meticulous system based on the sizes of the hand and the arm; and it is possible that other cultures, such as the Mesopotamic, had already developed similar systems or canons.

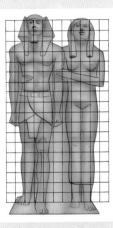

This diagram reconstructs the system of proportions used by Egyptian artists during the period of the Old Kingdom. The module is equivalent to the height of a fist and the figures measure a total of 18 modules.

THE MIDDLE AGES: A LONG PARENTHESES

In the Middle Ages, in contrast to Classical ideology, representations of the nude were limited to depicting figures of the Holy Bible. The concept of the nude was lost along with the holistic concept of man. Christian philosophy divided man into body and soul, the mortal flesh and the immortal soul. The higher existence was in the soul, in the spirit, while the body was considered an uncomfortable appendage that deserved no further attention.

The "Death" of the Nude

After the loss of pagan concepts, that is to say, after the disappearance of the symbols contained in the philosophy and art of Antiquity, the deep significance of the Classical nude disappeared as well. The vacuum left by these beliefs and ideals was occupied by the new and vigorous faith that Christianity brought with it.

The polytheistic beliefs that inspired the figures of Classical art became intolerable to Christianity's belief in a single God. The pagan figures were interpreted through the Christian value system as examples of idolatry or personifications of devils hidden beneath beautiful physical appearances. In the Medieval imagination, the nude figure was indissolubly linked to an interpretation as a devil. This association prevented artists from openly treating this subject for many centuries.

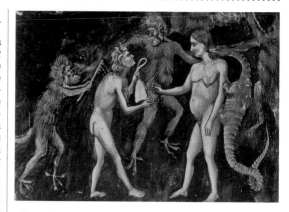

Giotto, The Last Judgment *(detail). Scrovegni Chapel, Padua. These nudes correspond to the last phase of the Middle Ages. The painter seems to have taken pleasure in accentuating the ugliness and deformations of the bodies.*

Medieval Alternatives

According to Medieval thought, the human body was little more than an embarrassing physical appendage to the soul, and Medieval representations only highlighted this sad condition. When, towards the eleventh century, figurative representation began to revive with the onset of Romanesque art in Europe, the only nudes appearing in reliefs and paintings were Adam and Eve or the souls condemned to hell. These Medieval nudes are simply the representation of misfortune. Formally, these representations had none of the harmoniously flowing lines nor the sensuality of volumes belonging to the Classical nude, and the artist sometimes even seemed to take pleasure in bringing out the physical ugliness of the figures. Medieval creators had lost the capacity to represent the human body convincingly.

Master of Maderuelo, The Creation of Adam and the Original Sin *(twelfth century). The Prado, Madrid. These are some exceptional examples of nudes carried out toward the end of the Middle Ages. The human figures here owe nothing to Antiquity, and anatomy is substituted by intertwining ornaments.*

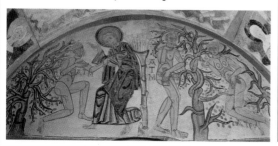

Mural paintings in the church of Santa Maria d'Aneu (thirteenth century). Museu d'Art de Catalunya, Barcelona. It is characteristic of Medieval painting for the human figure to fade into decorative lines and to occupy a place in the hierarchy of imagery hardly higher than the rest of the motifs (plants, animals, ornamental designs).

Art and Religion

More than in any other period, the relation between art and religion in the Middle Ages is profound and determines all of the imagery. Human representation has an explicative and symbolic intent. A series of conventions are used and ideal proportions and models of beauty are forgotten. For this reason, the first nudes appear again in relation to religion: the body of Christ on the cross, the body of Mary Magdalene, Adam and Eve, and so on.

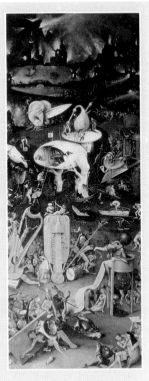

Hieronymous Bosch, The Garden of Delights. The Prado, Madrid. Hell, torments, and Christian symbolism occupy a central place in Medieval imagery.

The Gothic Nude

In thirteenth- and fourteenth-century art (which lasts well into the fifteenth century outside of Italy), the nude ceases to be an exceptional subject and its presence becomes common both in painting and sculpture. This allows us to establish certain general patterns that characterize the Gothic nude in clear contrast to Classical forms. The anatomy of Gothic art tends towards angularity, which contrasts dramatically with the curvilinear harmony of Antiquity. It is common for a Gothic nude figure to be represented in a violent gesture or movement with brusquely bent extremities. Furthermore, the ideal female nude's proportions are far different from those of the Classical Venus: round belly, narrow shoulders, and straight legs, with the facial features presented in great detail (an aspect that the artists of Antiquity always executed in a generic fashion). As you can observe, the Gothic nude, even in its latest phase, has little to do with the exercise in idealization of the human body characteristic of Greek and Roman statues.

Enguerrand Quarton, The Pieta of Villeneuve-les-Avignon. The Louvre, Paris. The Gothic nude is angular and uneven, and lacks the harmonious continuity of lines characteristic of Classical form.

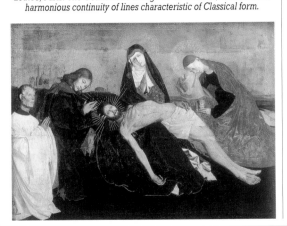

THE RENAISSANCE:
THE REBIRTH OF ANTIQUITY

The Italian Renaissance was truly the rebirth of Antiquity: Excavations in search of art from Ancient Rome uncovered an enormous amount of architectural ruins and sculptures that immediately became the canons for artists to follow. This desire to recover the past initiated in Florence during the first decades of the fifteenth century, and spread quickly to Rome and the entire North of Italy.

Return of the Classical Ideal

Already in the Middle Ages, toward 1300, some sculptors created works based directly on Classical pieces and done in accordance with the models of Antiquity. But these are exceptions to the rule in Medieval times. It was not until the second decade of the next century that the new Classical concept became definitively consolidated. The great pioneers of the Renaissance nude (the painter Masaccio and the sculptor Donatello) managed

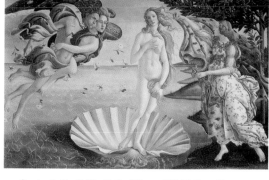

Sandro Botticelli, The Birth of Venus. *Uffizi Gallery, Florence. Botticelli represents the linear tendency of the fifteenth-century nude taken to the extreme.*

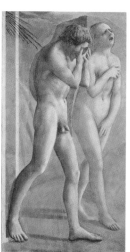

Masaccio, Adam and Eve Expelled from Paradise. *Brancacci Chapel, Carmine Church, Florence. Although the subject is purely Medieval, the treatment is already entirely Classical. Masaccio was the great pioneer of Renaissance Classicism.*

to impose this Classicism thanks to their particular talent for using purely Classical motifs in Christian contexts without contradicting the basic sentiments that these works were supposed to transmit.

The Nude in Fifteenth-Century Italy

The Renaissance took on different aspects according to the tastes of the court for which the artists worked (Florence, Venice, Ferrara, Mantua, and so on). It was precisely the courtly character of most of Renaissance production that conditioned the interpretation of the Classical nude. The Humanist values that these Italian courts adopted—that is, a taste for Platonic philosophy, for the intertwining of Christian and pagan symbolism, for allegories, and so on—are precisely reflected in pictorial

compositions that combine various nudes inspired in Antiquity and containing multiple symbolic and allegorical meanings.

Michelangelo, The Burial of Christ. *National Gallery, London. For Michelangelo, the human form, inspired in the statues of Antiquity, is the ultimate means of expressing emotions.*

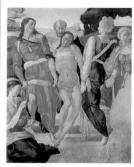

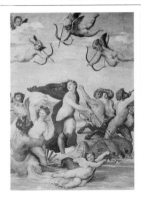

Raphael, The Triumph of Galatea. *Villa Farnesina, Rome. Raphael's harmonious nudes became the ultimate standard for all Classicist painters until the nineteenth century.*

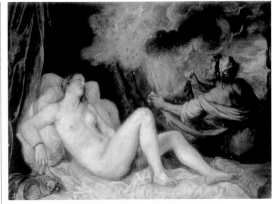

Titian, Danae. *The Prado, Madrid. With Titian, the Renaissance nude achieves a marvelously natural appearance, far from the linear emphasis of the Florentine Quattrocento.*

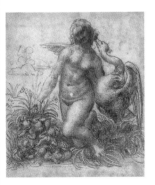

Leonardo da Vinci, Study for Leda. *Private collection. Leonardo's human forms are integrated into a natural setting to the point where they resemble the curvilinear plant forms surrounding them.*

Splendor of the Nude

The final stage of the Renaissance gave way to the splendors of the Baroque, a style that was not entirely Italian, although Italy remained the principal point of reference. Classicist values spread throughout Europe, and great masters came from the north as well as the south.

In Baroque art, the Classical nude reached its highest degree of expressiveness. Sixteenth-century Venetian painting marks the culminating point of the Renaissance. The three great Venetian artists are Titian, Veronese, and Tintoretto. These three painters took up the premises of the Classical nude, conceiving it as a harmonic whole, the result of the abstraction of form rather than the scrupulous observation of nature.

The Baroque Nude

Baroque art took Renaissance values and expanded them. It also signified the diffusion of the solid unity of purpose that had motivated the highest creations of the Renaissance. This movement lasted from the end of the sixteenth century to the middle of the eighteenth. It became the principal movement throughout Europe. Italy continued to occupy a central place in artistic creation, but the various local and national schools of Europe developed their own forms independently. Nonetheless, they shared numerous characteristics that provided stylistic unity to the entire period.

The Survival of Two Traditions

Although Baroque was a style common to all of Europe, and although at that time, artists could move freely from one country to another, gaining access to innovations and models to be followed, Europe could be divided into two major artistic traditions: the Nordic and the Southern schools (or the Gothic and the Classical traditions). Northern painters created a more realistic nude, more closely following the objective forms of the human body, whereas southern artists provided a more abstract rendition of the nude, in search of simple forms valid in and of themselves. These differences survive to the present day and can be seen in many contemporary figurative works of art.

THE NUDE IN MODERN TIMES

The reaction against traditional conventions and the search for radically new solutions are two characteristics of the avant-garde movements taking place during the first two decades of the twentieth century. Towards the end of the nineteenth century, the systematic use of the nude as an academic method had desensitized artists, who regarded the nude with increasingly waning enthusiasm.

Avant-garde Art and the Nude

The first Avant-garde artists attempted to return to basics and the essential principles of design. Those who chose the nude as a field of study (Matisse or Picasso), did so without considering any of the accepted and prestigious traditions that were regarded as immutable. Matisse took all sorts of liberties with regard to proportions in his search for a new harmony of lines and tonalities. But it was Picasso who went further in his rejection of academic ideals by inspiring himself with models completely foreign to Western art—the sculpture of Congolese cultures. Such insolence scandalized the public and fascinated young artists, who saw in Picasso's art a new way of approaching the human figure that owed nothing to the Classical tradition. His famous painting *Les demoiselles d'Avignon* gave rise to Cubism, a nearly

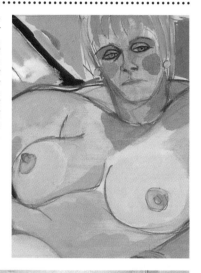

Detail of a nude done by Esther Olivé de Puig. Modern treatment of the nude often ignores academic norms and canons to achieve a more direct and uninhibited expression of the figure.

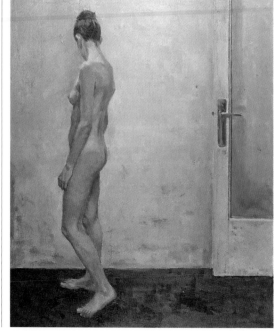

Badia Camps, Nude. Private collection. The Classical nude survives in strictly contemporary subjects, suggesting new possibilities to present-day creators.

entirely abstract style with no relation to the nude. The tendency toward abstraction predominated in all avant-garde movements, which saw the nude simply as an excuse or support for their graphic and chromatic experiments.

Paths Toward Modernity

The dissolution of the Classical ideals under the pressure of the Avant-garde had a liberating effect, but the new freedom brought with it a profound uncertainty. The canons of beauty and artistic perfection had been, if not completely abolished, at least seriously questioned, and no true artist could simply accept them. A characteristic of the development of contemporary art is the absence of a true period style and the continuous fluctuation of different ten-

Nude by Muntsa Calbó. The free style in which this painting was carried out (free brushstroke, liberal use of color) is characteristic of the modern nude. But under this appearance lie the plastic values of Classical form.

dencies, moving to the rhythm of the talent of individual creators or simply at the mercy of the fad of the moment.

The Nude As an Academic Discipline

Twentieth-century artistic experiments have also affected the way art is taught. As the Avant-garde's audacity was gradually accepted into the general artistic currents, academia slowly overcame its reticence and began adapting to the new times. Nonetheless, the various artistic works produced by a few original creators could not provide the base for a true pedagogical system in which a teaching method could be based on commonly accepted values and ideas. Despite the unquestionable brilliance of some new ideas in this area, no educational formula has yet succeeded in replacing the positive functionality of the nude as a method of learning.

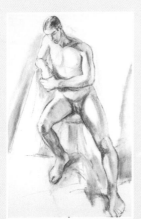

Drawing by Esther Olivé de Puig. The nude continues to be a common subject in academia.

Validity of the Classical Nude

The successive appearance of alternatives to the Classical style does not mean that this way of understanding the drawing and painting of figures has fallen into disuse. At present, the Classical model continues to be an essential reference point for many artists, who are inspired in the works of the past and consider the human figure to be the most suggestive of artistic subjects.

The great difference with respect to other artistic periods is that there is no unanimously recognized, undisputed authority (the academy, experts, or collectors), and therefore, artists depend on their personal criteria and on the ever-changing tastes of the public.

The nude as an artistic subject no longer has a single, absolute value, and its viability does not depend so much on the capacity of artists to make references to a glorious past, but rather on their particular talent for presenting their personal vision of the human figure convincingly.

THE NUDE AS A MEANS AND AS AN END

The relevance of the human figure throughout history is reason enough to attract the artist's interest. That relevance remains as valid today as in any other time period. In addition to its artistic interest in the sense of general culture, the human figure also provides many technical challenges.

The Nude As a Means of Learning

Drawing the human body requires a compendium of all the skills that an artist can develop in the treatment of real shapes and volumes. This subject matter calls for the use of all aptitudes of artistic representation, both in the proportionate organization of the parts with respect to the whole of the body, and in the representation of volumes, joints, planes, and simple shapes and their combination to form more complex shapes. Therefore, it can be said without exaggeration that a person capable of correctly depicting a human figure can also develop any other artistic subject matter, complicated though it may seem. Even if an artist's aims are far from representation according to the Classical model, the rigorous study of the figure is essential as a foundation for any personal expression. All modern artists who have developed personal visions of the figure (burlesque, surreal, fantastic, and so on) have

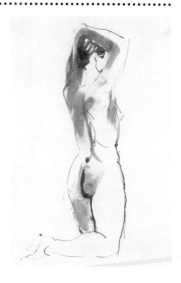

Sketch of a model by Muntsa Calbó. Practicing drawing nudes requires the exercise of one's powers of perception of form.

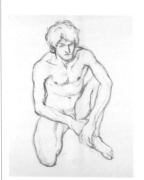

Drawing by Miquel Ferrón. In carrying out the nude, the formal concept counts just as much or more than the attempt at true-to-life representation of anatomy.

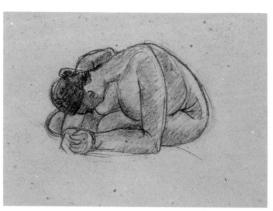

Sketch of a model by Muntsa Calbó. All graphic media is suitable for achieving the unity of forms, organic and articulated, on which the nude is based.

worked with a solid knowledge of the canon of figure drawing inherited from Classical models.

The Nude and Drawing

The exercise of drawing the nude activates the senses of visual perception while allowing you to practice the skills of the representation of form. The nude is a subject so rich in suggestiveness and evocativeness, that it can be approached from many different perspectives and in many particular styles without altering its essence. From an academic point of view, the nude is the best discipline for students, as it forces them to pay attention to proportions and trains them in calculating diverse shapes and sizes. The realization of a nude on the basis of contour lines or shading is one of the most thorough exercises that can be done.

Artistic Aim

As cold and distant as an artist's style may be, the

Form and Content

In figure painting, the question of content is more relevant than in other genres. In both still lifes and landscapes, the content consists of objects, and what comes to the foreground is the plastic realization of the subject. But in painting figures in real action, the human content of the work comes to the fore. The true artist cannot avoid participating emotionally, although this participation may be very limited. The expressive possibilities of this genre can be found through this emotional participation.

Auguste Rodin, Three cut-out figures on paper. Princeton University Library, New Jersey. The need for academic training cannot obviate the fact that the nude is, above all, a source of vital suggestiveness that should prevail over the literal copy of nature.

Sketch from a model, by Pere Mont. The whole of a nude can be expressed with few means, in a nearly shorthand fashion, as demonstrated in this excellent sketch.

motivation behind it is not simply the representation of a subject. Be it a work of great ambition or just a humble sketch, there is always an artistic, aesthetic aim that goes beyond pure representation or the technically correct copying of the subject in question.

This is also true of figure painting, and it becomes even more intense when dealing with nudes. The object, which is the human body, is charged with a suggestiveness that is much richer than any other pictorial subject matter.

THE MALE MODEL

To appropriately introduce the study of the nude, it is necessary to establish some general guidelines of proportion, guidelines useful for drawing all sorts of figures based on a technique of proportions adapted to our modern view of the human figure. Once this canon of measures has been studied and assimilated, it is much easier to interpret any figure.

Male Proportions

It can be said that there are three models or canons for drawing the male figure. One canon consists of seven and a half heads, which gives rise to a regular, nonstylized figure. Another canon is that of eight heads for a more stylized figure with harmonious proportions that have much in common with Greek statues of the Classical period. And finally, there is a canon of eight and a half heads, corresponding to a highly idealized figure, very athletic and closer to fictional heroes than to the real human figure. The Classical canon of eight heads is characterized by a diagram measuring eight heads in height and two in width. This means that the human figure can be blocked into a rectangle eight units high by two wide. This pattern not only provides the overall dimension of the figure, but also allows the different parts to be situated within the distribution of the modules.

Anatomical Distribution

The principal utility of the canon based on modules is that it allows the comparison and relation of the parts of the body based on references (the dividing lines between modules) that remain constant independently of the height of the real figure. This means that a short figure will have a relation among the parts of the body very similar to that of a tall figure. Shoulder height in the canonic diagram is approx- imately a third of a module beneath the head or, in other words, in the upper third of the second module from the top. The underarms are located at the line between the second and third modules. This line is also a good reference for situ- ating the nipples. The navel falls nearly, if not precisely, on the dividing line between the third and fourth modules. The same line indicates the position of the elbows as well as the height of the waist with relative accuracy. Along the central line of the diagram, that is to say, between the fourth and fifth modules, the hips and pubic area are located. Given that the hips extend from below the waist to the thighs, the best reference for situating them is their widest part, which would be located, as

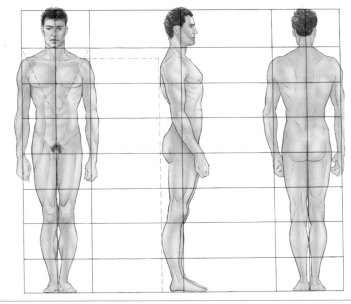

Frontal view, profile, and rear view of the canon of eight heads for the male nude.

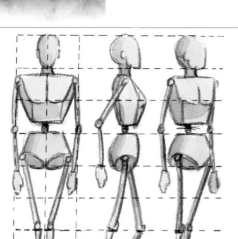

Thanks to the multiple references that the model of eight heads tall by two wide offers, it is possible to compose diagrams of male nudes in different positions but always maintaining the basic proportions.

Profile and Back

As opposed to the figure seen from the front, the profile of a figure is asymmetrical. This makes it especially important to pay attention to the relations among the parts of the body and the contours, checking the correspondence between the configurations of the front and the back. The most noteworthy aspect of the figure seen from behind is the clarity with which the line of symmetry or vertical axis is defined. This line is defined by the spinal column, the separation of the buttocks, and the inner contour of the legs. These reference points are very useful for drawing the figure from behind. (The majority of these anatomical aspects are visible from the front, as well.)

mentioned, along the dividing line between the fourth and fifth modules. The wrists are also located here, such that they are in line with the thighs. The knees are located along the dividing line between the sixth and seventh modules. It is important to note that this reference corresponds to the base of the kneecaps, or knees, while the knees themselves occupy the upper third of the sixth module.

Relative Widths

The above locations constitute the basic points of reference, but the module technique allows for width references as well, to ascertain the most important outlines. Two of the most important of these are the width of the head and neck, which take up approximately two thirds of

each of the two modules. The shoulders can be boxed with relative precision into the outer edges of the two modules, while the arms extend nearly a quarter of a module beyond the edges. The edges of the thorax occupy an outer third of the modules, while the width of the hips is located within the central area.

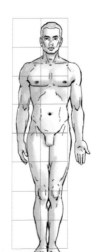

This is a sketch of the male figure inserted in a module diagram that is eight heads tall, the diagram most frequently used in learning to draw.

Profile References

It is interesting to ascertain the distribution of volume with regard to the central axis of the figure seen in profile. That axis can be imagined as a line that goes through the figure vertically from the top of the cranium, through the ear, the front of the arm, the center of the hip and thigh, the knee, and from there to the sole of the foot, along the outer edge of the shin. A figure standing firmly distributes its weight unevenly along both sides of the vertical axis.

THE FEMALE MODEL

Despite the obvious anatomical differences between the female and male figures, they both use the same canon of eight heads. The canon of the female figure is shorter, but her head is also smaller, such that the proportions are the same. It must be taken into account that, in reality, a figure can be seven and a half heads tall, or even less. Nonetheless, the proportions derived from the division into modules are usually the same.

Female Proportions

Although women are usually shorter than men, the canon of proportions of the female figure is also eight heads high because the woman's head is smaller. Once one is familiar with the anatomical distribution of the male figure in modules, it is easier to identify the important references for drawing the female figure. The greatest difference lies in the lesser width of the shoulders and greater width of the hips in the female body. The breast of the female figure is located lower than that of the male. Where the male figure's nipples fall along the dividing line between the second and third modules, in the female figure they are located in the upper third of the third module. The female waist, as the male's, is located along the dividing line between the third and fourth modules, but the female waist is narrower than the male's and it is closer to the breasts. In the female figure, the hips at their widest point also occupy the border between the fourth and fifth modules. In comparison with the male's, the female's hips are wider. The remaining references are practically identical for both male and female figures.

Therefore, drawing the female figure does not involve substantial variations with respect to the male figure once the generic outline has been blocked in.

The Profile, Back, and Torso

The profile of the female figure is smoother than that of the male in its transitions from one area to another. The arch of the back is somewhat more pronounced, the buttocks protrude somewhat beyond the vertical line from the shoulder blades, and the profile of the legs is not on such a diagonal as the male's. Seen from behind, the general characteristic that most stands out on the female figure is the clean contour of the back and hips, set off by the waist. The back is an inverted triangle, nearly without relief to disturb its profile. The point of this triangle fits into the hips, which, in com-

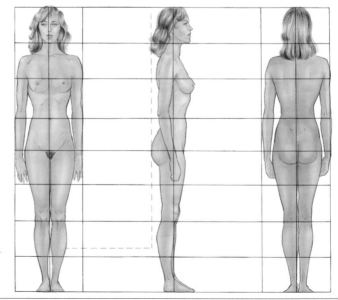

The female canon has the same proportions as the male canon, although the configuration of the anatomic relief varies significantly.

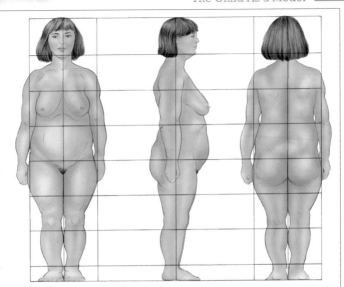

Many figures correspond more closely to a canon of seven and a half heads. But in this case as well, the relations between the modules and the parts of the body are maintained.

parison with the male figure, take up a greater space. The female figure also has the reference that is so important to drawing—the vertical axis formed by the line running down the spinal column, continuing through the buttocks and down the inner face of the legs.

The relief of the female torso, from both the front and the back, is much less conditioned by the muscular anatomy that characterizes the male figure, and the transition from one area to another is much smoother.

One of the essential factors for achieving a good drawing of the female figure, in the frontal as well as the back views, is to place the waist at the correct height (higher than for the male), as the waist is the anatomical aspect that gives the feminine figure its characteristic shape.

Comparing Canons

It is an excellent exercise to project the canons of the male and female proportions onto real models. Upon carrying this out, it becomes evident

that the male figure more clearly fits into the canon of eight heads, whereas the female in reality measures approximately seven and a half heads. This is normal: it is logical that the real measures be somewhat smaller than the canonical measures, as these are, after all, idealized measures and not real ones. But the interesting point of these comparisons is to verify that, although the proportion of the real figure may not coincide completely with the canon, the anatomical parts of the body really do coincide with the reference points of the modules previously described (shoulders, chest, waist, elbows, hips, and so on). Thanks to this coincidence of points, the canon of proportions is an

extraordinarily useful tool for becoming familiar with, and ultimately memorizing the distribution and relative sizes of the parts of the body with respect to the whole. Once these rules have been memorized, it is much easier to draw a figure, whether from a model or from the imagination. The most important factor is not that the figure measure eight or seven heads, but that the distribution of the modules serve as a pattern for the construction of a truly proportionate drawing.

Ideal and Reality

It would be useless to study the canon of human proportions in great depth without comparing it to reality. Ultimately, artists base their works on what they see in the real world and not on learned theories. The theories serve as an essential aid, but it is the study of the real model that determines the final result of any figure drawing.

THE CHILD AS A MODEL

In the drawing of child figures, the canon is important, but not as reliable as the canon for the adult figure, due to the great differences in proportion caused by growth. The most important factors to remember when drawing children are the larger size of the head and the shorter length of the arms and legs with respect to the trunk of the body.

Growth and the Model of Proportions for a Child

Any model of proportions for a child figure will inevitably be partial, as the anatomy in this stage of life is constantly evolving and proportions change greatly in very few years. Nonetheless, different stages of child development can be compared, and we can study the basic proportions of the anatomy at the most significant stages of development. In the first two years of age, a child's body measures the equivalent of four heads, as the child's head is double the proportion of an adult's. This is the fundamental feature to be kept in mind when drawing children: the head is always much larger in relation to the rest of the body. This characteristic becomes proportionately less as development advances, but does not entirely disappear until the child reaches adulthood.

Four Years of Age and Older

In the anatomical development of a child four years of age, the head continues to be proportionately very large, but the growth of the body makes the height now five modules and not four. The trunk is wider and the chest becomes taller in relation to the abdomen, which in the previous stages constituted the majority of the trunk. The hips also

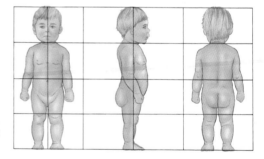

Proportions of a two-year-old child. The head is proportionately much larger than that of an adult.

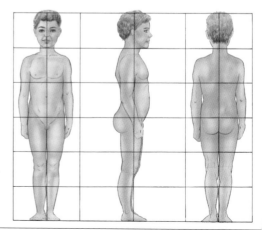

Canon of proportions of a six-year-old child. During development, the proportions differ significantly from those of an adult, especially in the size of the head.

Marià Fortuny, The Flute Player. Fortuny collection, Royal Academy of Fine Arts of St. George, Barcelona. The proportions of a child between eight and ten years of age can be studied better in this work than in a graphic diagram.

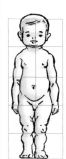
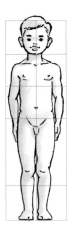
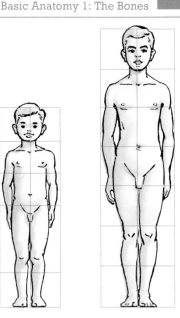

Comparative proportions of the three phases of child growth (from left to right): a two-year-old, a six-year-old, and a twelve-year-old child.

grow longer, and the relation in size between the trunk and the legs becomes closer to that of an adult.

At about six years of age, the above anatomical changes in the child become more pronounced, and the proportion of the body becomes equivalent to six heads in height. At this age, there is still a certain disproportion between the chest and the hips, which are nearly the same width, and the trunk is proportionally somewhat longer than a normal, fully grown body.

In a twelve-year-old child, the height of the body is equivalent to seven heads and shows all of the characteristics of the adult body.

The Shape of a Child's Body

Often in drawings or paintings (e.g., mythological, maternity scenes) with nude children, the treatment is correct but not very realistic insofar as shape. When drawing child nudes, the rounded shapes of the child's anatomy

must be considered and even exaggerated. Angles must be avoided, as well as straight lines that are too strong. It is always preferable to intensify the undulating movement of the outlines than to excessively worry about the perfection of the proportions. In

any case, children, especially very young ones, are undergoing growth, making their proportions less defined. It is therefore useless to attempt to establish them with the same precision as for the canon of the male or female adult.

Representations of Children in Classical Painting

In Renaissance and Baroque painting, representations of child figures abound: angels, cupids, and a long series of iconographic figures represented as children. The pictorial sensuality of lines and colors, as well as the inherent grace of these types of figures make child representations one of the intrinsically charming features of Western Classical painting.

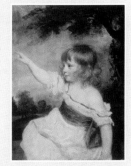

Joshua Reynolds, Master Hare. The Louvre, Paris.

BASIC ANATOMY 1: THE BONES

Once you have become familiar with the canons of proportion of the human figure, it is interesting to relate them to the internal anatomical structure. This structure is responsible for the physiognomy of the body and conditions both the shape of the body parts and their movement. Familiarity with basic anatomical features is essential in order to achieve well-shaped, unitary, and correctly articulated representations of the human figure.

The Skeleton

The skeleton is the framework of the anatomy, the rigid structure that provides solidity to the body. This structure is composed of articulated parts (the bones). The articulations (the joints) are the connections between the different bones that allow for movement. In general, the shape of the bones cannot be deduced from the relief of the naked body, but there are significant excep-

Three views (frontal, back, and profile) of the human skeleton. The artist must be able to imagine the shapes of the nude when viewing a skeleton. If, in addition, the comprehension of the bone structure is accompanied by a clear notion of the proportions of a figure, it is easy to grasp the general configuration of the skeleton without knowing the anatomical details of its composition.

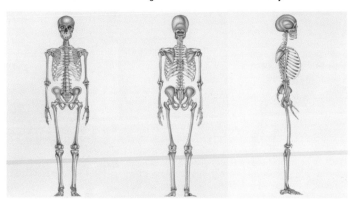

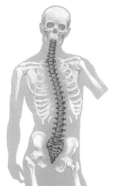

The spinal column can transmit the movement of the body throughout the torso thanks to the great deal of articulations composing it.

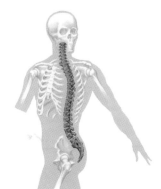

The trunk can twist because of the many possibilities of movement of the set of vertebrae composing the spinal column.

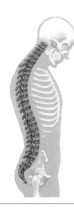

The profile of the back is always defined by the movement of the spinal column.

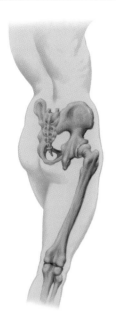

The pelvis is the anchoring bone for the legs and the trunk. Its articulation allows the movement of the body.

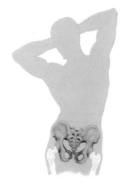

The pelvis allows the inclination of the trunk in relation to the legs in the characteristic balancing movements typical of nude poses.

tions. For example, the collarbones, shoulder blades, elbows, knuckles and fingers, knees and heels, as well as the cheekbones, eye sockets, and occasionally the chin, are often visible. All of these volumes and protuberances are visible in a naked body. For the artist it is important to have a clear idea of the internal skeletal distribution in order to make the relief produced by certain bones against the skin more or less pronounced. It is an interesting exercise to imagine the human body when viewing a skeleton from the front, side or back, not only because the proportions among the anatomical parts are more clearly visible in relation to the whole, but also because the logic that governs joint movements can be seen.

Basic Articulations

We will discuss certain basic joints here whose movements are decisive for the shape of the human body.

First of all, we must discuss the spinal column. The column is the central axis of the trunk and runs through it from top to bottom. It consists of 24 vertebrae and ends in a larger bone called the sacrum. This set of bones is articulated to allow frontward, backward, and sideward movements as well as torsion. The spinal column is responsible for the profile of the back in the body's different postures.

The second basic articulation is the pelvis, which not only allows the movement of legs in locomotion, but also allows them and the torso a full range of articulated movement including torsion. Its shape and contours condition the appearance of the hips.

Bone and Muscular Relief

Bone relief visible in the nude (such as collar bones, elbows, and knees) must be clearly distinguished from muscular relief. The latter is very flexible, and changes according to the position of the body and the tension applied, whereas bone relief is constant and rigid at all times, with no changes due to movement.

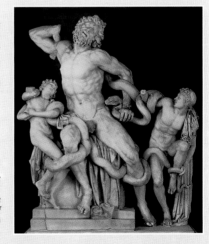

In this detail of the Hellenistic sculpture of Laocoon and his sons, the muscular relief of the torso is highly visible. The bone relief (clavicles, sternum, and lower ribs) is independent of muscular volumes.

BASIC ANATOMY 2: THE MUSCLES

The muscular distribution of the human body is much richer and more complex than its bone structure. There are many more muscles than bones in the body, their shape is less defined and their volume varies according to movement. The muscles cover most of the bones and give the human figure its characteristic relief.

Muscular Structure

The highly complex muscular structure of the body is similar to packaging composed of overlapping elastic parts that cover the bones and internal organs. The muscles are directly responsible for movement and anatomical relief. The shape of the muscles depends on their function in the movement of body parts. They can be classified as circular (ring-like in shape, with the function of closing vessels), orbicular (rather flat, such as the muscles around the eyes), flat and wide (such as those of the forehead), fan-shaped (such as those in the back), and spindle-shaped (such as those that move the arms and legs).

Muscles and Movement

The majority of movements that occur in the body are

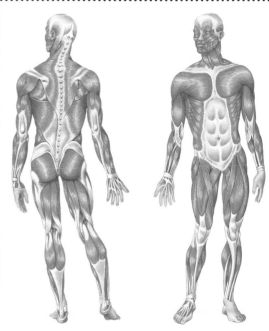

Back and front view of the muscles of the human body. The muscular structure of the body is truly complex, but it is interesting to have these images as a reference to verify the accuracy of anatomic relief in a drawing.

The flexion and extension of the arm is governed by the principle of the fulcrum, in which the strength of the muscle is opposed to the resistance of the weight being lifted. The movement (and the increase in volume) is possible due to the fulcrum point provided by the elbow. The same principle governs the movement of most muscles.

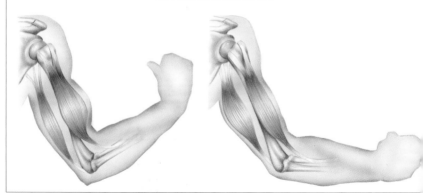

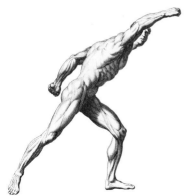

This is an ancient engraving, inspired by a Greek statue, in which the body appears as if "skinned" so that the artist can see the distribution and movement of the muscles.

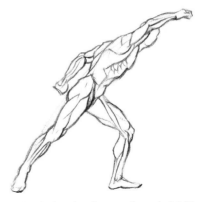

A drawing based on the engraving to the left. The lines provide a schematic outline of all of the anatomical relief such that the body becomes a conglomerate of coordinated parts.

governed by the principle of the fulcrum, based on a point of support on which two opposing forces act, pull and resistance. This effect can be easily verified by lifting a weight with your arm. The pull is provided by the biceps muscle, while the resistance is found in the weight itself. The fulcrum point is none other than the elbow joint. This movement causes the muscular relief that is best known, the biceps, a muscle that has become a symbol of physical strength.

Muscle fibers have the capacity to contract and elongate, and this is precisely what allows movement. When a muscle contracts, it makes the part of the body that it is pulling rise. When it relaxes, it allows the part of the body to descend. Naturally, in the majority of movements, more than one muscle is involved, and sometimes nearly all of the muscles of the body are involved. In lifting a weight, for example, or going up stairs, the body would lose its balance if the entire muscular system did not react immediately and precisely to compensate the tension of one of its parts.

Muscular Study

Ancient drawing manuals always contained "skinned" models for students to practice drawing muscles in movement. These figures were based on ancient statues, and they showed all the muscles in the shapes and tension corresponding to movement.

These methods have fallen into disuse. Today, academies prefer real-life models and emphasize the muscular relief of the specific person involved, without stylization.

The Anatomical Study in the Renaissance

Their passion for the human body moved the great artists of the Italian Renaissance to study anatomy through corpses. Michelangelo and Leonardo da Vinci dissected corpses in secret, risking their careers as famous artists, as this was prohibited at the time, even for medical purposes. Their zealousness for first-hand knowledge of the body was rewarded by the perfection of their drawings and paintings, which survive as models of excellence.

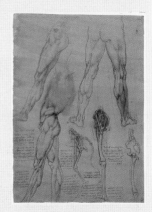

Leonardo da Vinci, **Study of Legs.** *Windsor Castle. These magnificent drawings are the result of an in-depth study of the human anatomy.*

ANATOMY AND ARTISTIC DRAWING

You need not be an expert in bone and muscular anatomy to draw a skeleton or a general overview of the muscles of the body. Such exercises are of great interest to the artist, as they promote a deep comprehension of the relief and movement characteristic of the nude figure.

Sketch of the Skeleton

It is easy to sketch the human skeleton based on the detailed reproductions appearing on the previous pages. Drawing a schematic skeleton requires comprehension of the forms constituting the body's frame. The head should be drawn with its characteristic shape, rounded but not completely spherical. The spinal column should be the axis of the body and its movement, always slightly sinuous (with an S shape, never completely straight). The ribs can be schematized as a more or less oval and compact mass. The pelvis is triangular and curved along its edges. The leg bones attached to the pelvis should not be drawn completely vertically, but rather tilted toward the center (from the pelvis toward the knees). The rest of the leg and arm bones can be sketched in as straight lines. All of this must be kept to logical proportions within the scheme or canon described previously. On the basis of this

sketch, different skeletons can be carried out in various positions, with the adequate bone placement for each of the movements or poses. Carrying this exercise out correctly leads to skill in the conception of movement and proportions in the nude.

Bones, Muscles, and Anatomical Relief

Another interesting exercise consists of carrying out successive drawings of the skeleton, muscles, and the body "with skin" on sheets of tracing paper, and then superimposing them to achieve an image of all of these aspects simultaneously.

Naturally, the pose or move-

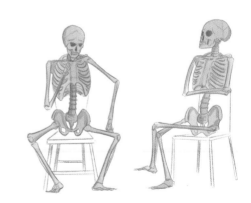

Using simple schematic drawings, skeletons in different positions and in movement can be drawn. Drawings of this type provide a solid understanding of the basic articulation of movement in the figure.

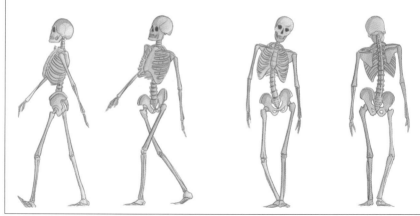

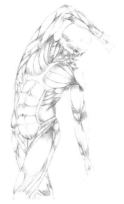

ment must be the same for each of the three drawings. In the example on this page, a pose was chosen with a great deal of movement, but the illustrations of bones and muscles on previous pages can also be used for this exercise. Once you have done this exercise, you can use photographs and tracing paper to work backwards, from the real figure to the muscular and bone structures.

First a simple drawing is traced of the nude, without much detail. The second step is to cover this drawing with tracing paper and draw in the skeletal structure (using the image of the skeleton provided as a reference). The bones should be drawn with the greatest precision possible, beginning with the ribs, the cranium, the spinal column, and the pelvis, and following with the detailed drawing of each bone. Real slants and articulations should be drawn accurately, without adding undue bends. Finally, another sheet of tracing paper is superimposed on this one and the muscles are drawn in, using the corresponding illustration as a guide. The exact location of each muscle should be carefully ascertained and each one should be given the appropriate shape and size.

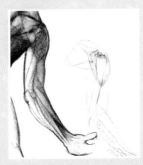

The first three drawings of this series correspond to three phases of a useful exercise in anatomical comprehension. Each of them is drawn on a separate sheet of tracing paper. When these are superimposed, an image is obtained in which the skeletal system, the distribution of muscles, and the anatomical relief of a nude can all be observed simultaneously.

MORE ON THIS SUBJECT

• Basic Anatomy 1: The Bones **p. 22**
• Basic Anatomy 2: The Muscles **p. 24**

Art and Anatomy

Since the magnificent anatomical studies carried out by Leonardo da Vinci, artists of all periods and styles have deepened their knowledge of bone and muscle structure in order to further the expression of the nude through the veracity and accuracy provided by the scientific knowledge of the body. But anatomical form would only be another aspect of medical science, cold and antiseptic, if it were not imbued with the sensibility that only an artist can provide.

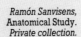

Ramón Sanvisens, Anatomical Study. Private collection.

THE ARTICULATED MANNEQUIN

An articulated mannequin can simulate the majority of human positions or movements (standing, sitting, resting, in movement, walking, running, jumping, and so on). It is designed in such a way that its system of articulations does not allow it to effect any positions that the human body could not take on.

An Aid for the Artist

Draftsmen and painters since the Renaissance have used the articulated mannequin as a tool. The ancient models were true pieces of handicraft, with painstakingly calculated articulations (which sometimes even included the fingers), and they could even be as large as life size. Those amazing mannequins were often used by the great masters to substitute for real models. For example, when they had to portray a monarch or important lord, and he would not pose for more than a few sessions for the painter to carry out the facial features, then the artist would dress the mannequin in the appropriate clothes and set it in the desired pose. They were also used to invent scenes with

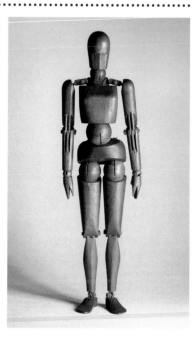

This is a high-quality articulated mannequin made of wood. It is similar to those that can be bought today in fine arts stores.

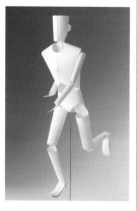

For people with time and patience, it is possible to construct a mannequin of somewhat rigid paper or cardboard, held up on a wire set in a base. The articulations of the joints can be achieved by bending the figure in the appropriate places.

characters in all sorts of positions, saving the painter from having to pay real models. A drawing done from an articulated mannequin can never substitute for one done from a real model, but it is an invaluable aid to draftsmen and painters who are carrying out the human figure from the imagination. Indeed, it is often necessary to represent movement, as sketches done from the imagination sometimes do not succeed in expressing it. In such cases, it is highly useful to resort to an articulated mannequin to compose the exact posture desired and succeed in drawing a figure in that posture more easily.

The Mannequin As a Model of the Nude

Drawing the human figure from memory (without looking at a model) is one of the essential skills of any artist. Being able to imagine and represent figures in all sorts of positions is essential for both the artistic draftsman and the commercial illustrator. Nonetheless, certain postures often present particular problems or uncertainties as to the form, proportion, or movement that can only be resolved by observing a real model or an articulated mannequin. The mannequin is a three-dimensional schematic representation of the human figure. It is like a blocked-in diagram of the

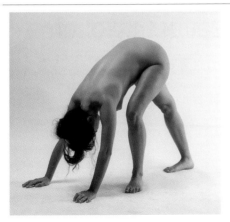

Even this somewhat unnatural position can be replicated with considerable accuracy using a mannequin.

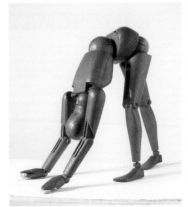

If the mannequin is high quality, then it will remain stable in poses such as this one.

anatomy using simple shapes that schematize the basic areas of the human body.

Schematic Parts

The part of the mannequin corresponding to the head of the nude has been simplified to an oval lacking facial features. Nonetheless, it does have a slight indentation in the front that corresponds to the symmetrical center of the face and allows the position of the nose to be calculated as the basic reference for the rest of the facial features. The thorax is a somewhat more complex part. The front side has a protruding plane to represent the shape of the chest, whereas the back side is flat. The hips are a cylindrical body affixed to the thorax through a large articulation (the waist). Both sides are the same, with an inclined plane towards the bottom to express the configuration of the lower part of the abdomen (front view) and of the buttocks (rear view). The arms and legs are simple shapes similar to cylinders whose lengths coincide proportionately with those of the upper arms, lower arms, thighs, and calves. The hands and feet are curved on the outside and flat on the inside.

It is easy to carry out schematic designs of the human skeleton based on a mannequin in any position. This exercise helps you gain a deeper understanding of the articulation of body parts.

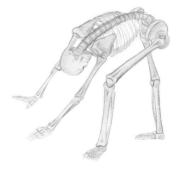

Their shape is a schematic simplification of the shape and proportions of the hands and feet.

Reproduction of Poses

Another interesting feature of the mannequin is that it can be placed on its feet to test the possibilities of equilibrium for the human figure, such that if the mannequin cannot stand in a certain position, then that position is not possible for a real person either, unless the person is in movement.

From Miniature to Life Size

There are articulated mannequins on the market in various sizes, ranging from a 25-cm-tall miniature to the life-size version, made of wood and with a hand-made finish on all of the joints. In addition, there are also horse mannequins available with an ingenious and sophisticated system of articulations. The most recommendable (for its usefulness and price) is the 35-cm version, which allows all sorts of poses and can be handled easily.

FROM THE MANNEQUIN TO THE NUDE

The mannequin allows the artist to become familiar with the proportions of the figure and with its movement without making the many errors that arise when working from memory or a photograph as the only references. The mannequin allows the representation of a pose from all possible points of view, studying foreshortening and positions that would otherwise be difficult to view.

Initial Sketches

The articulated mannequin is really a blocked-in human figure in three dimensions. If we copy the parts that it is composed of, we obtain a perfect blocking in, into which the contours of the real figure can be inserted. It is important to become familiar with these parts, first drawing them separately and then assembled to verify the way they connect and how they compare to real joints of the figure. As a preliminary step in figure drawing, the pose of the figure must be sketched in. This consists of the basic lines representing the body parts with no reference to volume. These lines must be done in proportion and should create an appropriate sense of movement. The mannequin makes this task easier, as it is itself like a three-dimensional sketch.

Volumes

Although the parts of the mannequin are simply an approximation of the real volume of the body, it is best to suggest volume to provide orientation for the following process of realizing the nude. These parts must be done in correct proportion with regards to both length as well as width, because then the drawing will always correspond to the real form of a human body. If the position chosen for the mannequin is not complicated, the volumetric sketch should pose no difficulty.

Slight Modifications

Some slight modifications must be carried out to adjust the schematic shapes of the mannequin to the organic ones of the nude. For example, the shoulders of the mannequin in a vertical position are nor-

The articulated mannequin permits the reproduction of nearly any static pose of the human body.

After making a complete sketch based on the parts of the mannequin, the joints and body parts must be rounded off (in this case with a marker) to add the basic anatomical features of the male or female figure.

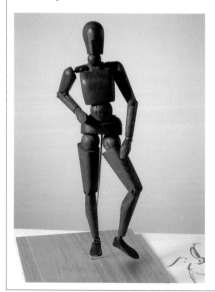

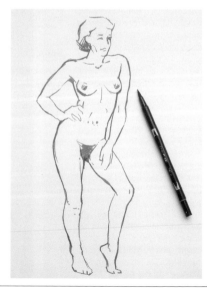

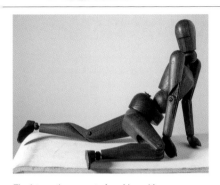

The interesting aspect of working with a mannequin is that it can hold difficult poses for as long as necessary.

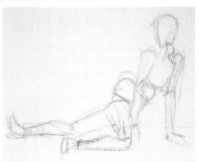

The sketching of the pose is facilitated by the mannequin's clearly distributed and simple parts.

mally at the same height in the majority of positions. But if a more natural pose is desired, it is best to take the inclination of the thorax toward one side as a reference in the majority of poses, toward the side with the leg that is further forward (and takes the greater part of the weight of the body) in a typical counterbalancing position. This inclination should be indicated by positioning the shoulders at different heights to give the nude a sensation of natural movement.

Furthermore, naturally, the transitions between the parts must be softened using the characteristic contours of the anatomy to provide a more natural movement to the joints. The muscular relief of the body parts carrying most of the weight should be slightly exaggerated to avoid the rigidity of the mannequin.

Anatomic Results

A certain familiarity with the anatomy of the body is essential to definitively finish the drawing. It is still necessary to add, from memory, the volumes and contours of the chest, hips, head, elbows and knees, as well as the series of curvatures caused by the muscles throughout the body. But thanks to the

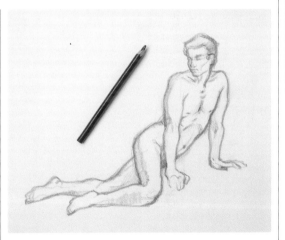

In this case, the sketch was rounded off with a charcoal pencil to give the figure the anatomical features of a male. This rounding off is an essential step that the artist must take with a sketch done from a mannequin.

aid of the mannequin, problems of proportion and movement are solved from the very beginning.

MORE ON THIS SUBJECT

• The Articulated Mannequin **p. 28**
• Position and Movement **p. 56**
• Balance **p. 58**

Intuitive Anatomy

Continuous practice in drawing nudes eventually lends the artist an intuitive knowledge of the male and female anatomy that allows each pose to be executed nearly automatically, with the positioning and proportions of all the contours being carried out correctly. This knowledge is obtained through the study and correction of previous errors, and by continually keeping in mind the basic canons of proportion and the essential anatomic configuration of the body.

THE HEAD AND FACE

There is no need to be experienced in drawing or painting to realize that one of the most attractive aspects of a work with a figure is the head. In the nude as well, interest tends to center on the head, the facial features, and their expression.

Position of the Head

First of all, the position of the head on the nude must have a logical relation to the rest of the body. The movement of the head is more or less free, depending on the pose of the model, but always related to the position of the shoulders and back. The position of the head must be established within the early phases of the work in the preliminary sketch. The majority of artists adjust the shape, proportion, and inclination of the head by drawing an oval on which they draw lines indicating the position in which the facial features are to appear. When positioning these elements on the generic shape of the head, their appearance and physiognomy do not matter. Only the specific positions matter. If these are correct, it is easy to add the personal detail.

The internal bone and muscular structure of the head can be schematized by sketching a semicircle and adding the characteristic shape of the chin. In overview, the whole is equivalent to an oval.

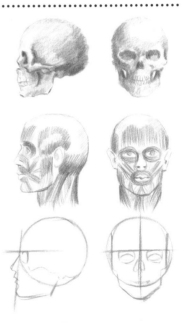

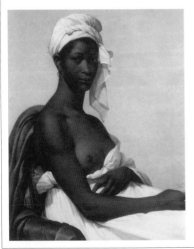

Marie Guillemine Benoist, Portrait of a Black Woman. The Louvre, Paris. In any nude, the position of the head must be part of the general composition of the work.

Modules for the Facial Features

If we consider the face seen from the front as an oval, the position of the eyes can be indicated with a horizontal line drawn approximately in the center of the oval. The base of the nose is located at the point that divides the bottom half of the oval, and the mouth is located about halfway between this and the chin. If we add a line for the eyebrows, we will have a good sketch for the head and facial features. It is easy to block in and draw a face seen from the front or in profile, but it is not so easy to do the same with heads in apparent upward, downward, or sideward movement.

The lines or partitions previously created must then be

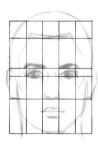 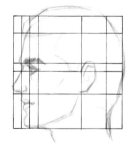

These are the lines or modules that provide the relative location of the features on the head.

Although the hair be very dark, it should never be realized in a tone that is too dark and thus contrast too much with the tones of the face. In certain areas, the dark tone should gradually become lighter to blend with the lighter tones of the face and neck. In this way, the hair seems to truly grow from the structure of the head. Another interesting technique is to apply single brushstrokes that express the lightness of the hair, avoiding the portrayal of an overly heavy mass.

curved in perspective to follow the oval shape of the head. If the oval with the corresponding curved lines is modified to correspond with different perspectives, the curved lines and points of reference are also modified with perfect accuracy for the blocking in of a head in movement.

Eyes, Nose, Mouth, and Ears

To indicate the position of the eyebrows and eyes on a nude, lines must be drawn corresponding to the eyebrows and upper eyelashes. In this manner, the error of drawing the whole of the eye too large is avoided, as its overall importance in the figure is minimum despite its psychological significance. The nose is often executed in an inefficient manner through a single brushstroke or line. To treat it correctly, its form (which changes with each model) must be attentively observed, as well as its volume and shadows. Its elongation or foreshortening due to the position of the head and the artist's point of view must be interpreted in the work. The mouth is often handled with excess precision. We must not forget that we are carrying out an entire nude and not just a portrait of a face. It is an error to make the facial features too detailed.

When they are not concealed by hair, the ears only serve to mark the side limits of the face. That is their principal and only function in the nude. Establishing the right height for the ears is almost always extremely difficult. Nonetheless, this difficulty is attenuated through the reference points of the nose and eyes.

Longitudinal divisions of the head allow the facial features to be blocked in. By adjusting these divisions to the oval of the head, the factions can be easily located, no matter what position the head is in.

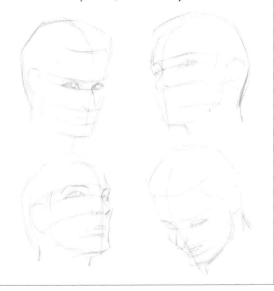

THE HANDS

The shape of the hands must be in harmony with the style, size, and position of the rest of the figure. To be able to guarantee their correct resolution in a nude, they must be observed and studied from the beginning, just as the rest of the body parts, to comprehend their shape and the causes that determine their position.

Proportions of the Hands

The hand is the body part that offers the greatest possible range of positions. It can be seen from above, from below, frontally, from further side, closed, open, and with the fingers in an infinity of different positions. Students learning to draw will frequently take on the subject of the hand with no preparation, attempting to copy what they see with no further aid than their capacity for imitating reality. The results are usually disappointing: deformed hands with overly thick or short fingers; hands that appear to have too many fingers or that look more like animal paws than human hands.

To establish their basic proportions, the hands can be divided into two principal parts: the palm and the fingers. If the entire dimension of the open hand is considered as seen from the back, it can be seen that the distance from the wrist to the knuckles is the same as that from the knuckles to the tip of the middle finger (the longest finger). If this measure is applied to the hand when it is face up, the dividing line between both halves usually lies along the protuberances just below the fingers, more or less at the base of the pinky. Other facts that are just as important can be observed by simply opening the palm of your hand. For example, when the fingers are extended, the length of the index finger is the same as that of the ring finger. These observations allow you to easily calculate the proportions of each finger within the whole, except for the thumb.

The Thumb

The normal position of the thumb (when the hand is extended and relaxed) is a semicircle that begins in the center of the base of the palm. Once the radius that the thumb can describe is established, it is easy to calculate the different positions that it can take when the palm remains extended. If you turn over your hand, you can see how the radius of movement of the thumb can be prolonged in an imaginary line to coincide with the middle joints of the other fingers. This is an essential fact to keep in mind for drawing hands in all sorts of positions. The knuckles and joints of the fingers can always be connected by a curved line (ascending or descending, open or closed) that will distribute

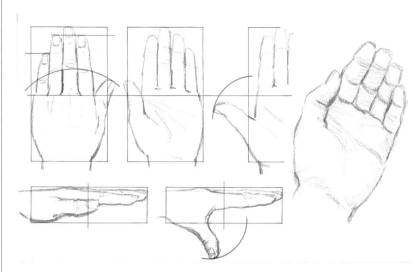

These sketches show how to understand the position and movement of the thumb. Its movement follows an arc along the side of the hand, as well as an arc moving downward from the palm.

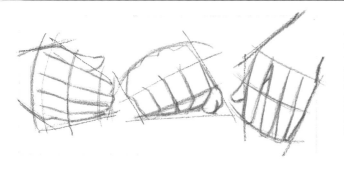

The movement of the fingers corresponds to a constant pattern—the arc that their joints form, a series of concentric arcs that facilitate the resolution of their form in any position.

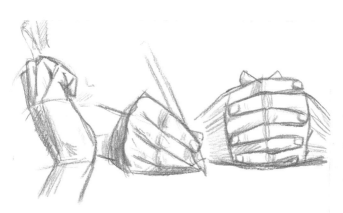

It is important to practice by drawing your own hands directly as well as with the help of a mirror to solve the problem of always drawing the left or right hand (depending on whether you are right or left-handed).

them in the correct proportions. Drawing this curve into the sketch of the hand will make the drawing much easier to do. If you observe your hand from the side, you will notice that the thumb is nearly seen from the front, the opposite of looking at the hand with the palm side up. We can also observe the radius of movement described by the thumb when it moves downward from the palm. This movement begins at the base of the thumb very close to the wrist.

Hand Sketches

To draw hands in proportion, they should be blocked in with simple shapes. The hands can take on different appearances depending on the point of view and the position of the fingers, and each of these positions requires a special blocking in. The shapes used to block in should be very simple: squares, rectangles, triangles, and blocks composed of combinations of these. The important thing is that the dimensions of the block of the entire hand and of each of its sides correspond to the correct proportions of the hand.

MORE ON THIS SUBJECT
• Basic Anatomy 1: The Bones **p. 22**
• The Hands and Feet: Their Importance in the Nude **p. 36**

From Complex to Simple

Although in many drawings of the nude, the hands occupy a secondary place, it is essential to master their configuration, movement, and proportion within the figure. Only in this way can they be summed up in a few simple lines without the effect being strange or incomprehensible. As in every other aspect related to the nude, realization of hands begins with practicing their complexity until you reach the capacity to sum them up in a few brushstrokes or lines.

THE HANDS AND FEET: THEIR IMPORTANCE IN THE NUDE

The hands and feet are the areas where the human form is the most complex, where large body parts give rise to small, nearly independent elements, where a generic or approximate solution based on a model or canon is not enough. The drawing must be precise and true to reality.

Proportions of the Feet

Drawing a foot is not as difficult as a hand. Although anatomically, the number of articulations is the same for both, the real possibilities for movement are much less for the feet. This limitation results in a more homogenous, continuous shape with far less relief. In addition, the near absence of articulation prevents the problems of wrinkles and folds of the skin so typical when drawing the hands.

In a foot seen in profile, the area of the toes takes up some-

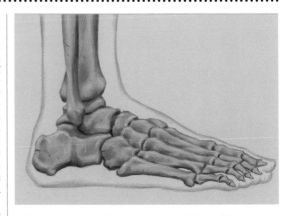

The bone structure of the foot is very complicated and is composed of many little bones. Nonetheless, this complexity affects the external anatomical appearance very little, given the little mobility of the foot in relation to the hand.

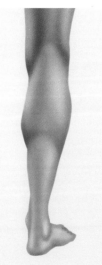

It is important to study how the leg fits into the heel and foot. The calf becomes thinner (given the absence of large muscles near the ankle) and then the bones of the heel appear.

what less than a fourth of the length of the entire foot from the heel to the tip of the big toe. This is a useful reference to ensure correct proportion for a drawing. Drawing the foot in profile is very simple. It fits entirely into a triangular blocking in. The shape is clearly delineated by the angle of the heel, which is the area carrying the majority of the weight of the body. The frontal view of the foot presents some problems due to foreshortening. Nonetheless, it can also fit into a triangular shape, although much narrower

An interesting detail in drawing the feet is that the bones protruding on each side of the ankle are not at the same height. They are lower on the outside of the foot.

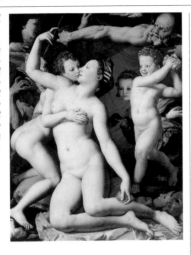

Bronzino, Allegory of Venus and Cupid. The National Gallery, London. In works such as this one, the importance placed on the gesture of the hands in the subject of the work can be observed. The feet also play a more relevant role than usual in the nude.

than the one used for the foot in profile.

Gestures

Although in contemporary art, hand gestures have lost the charge of meaning that they had in some points of art history (for example, during the Gothic period), they still have an expressive value.

We know that specific hand gestures or movements have meaning: elegance, fatigue, energy, and so on. The artist must be conscious of this and give the right instructions to the model so that the gesture of the hands is in consonance with the chosen pose.

In a reclining figure, whether relaxed or sleeping, the position and gesture of the hands must avoid all signs of tension or complication. The simplest of gestures and postures must be chosen. If the figure is active, holding some object, combing his or her hair, for example, the artist should be careful in expressing the right movement and gesture to show that the person is *really* holding the object. It is common in unsuccessful pieces that the hands appear to be stuck onto the object because they are too soft or not positioned right.

Representing the feet is easier, as they do not have the possibilities of movement or expression of the hands.

Unfinished Hands and Feet

After the previous section, it could seem contradictory to speak of unfinished hands and feet. Nevertheless, leaving something unfinished does not mean doing it wrong, but simply not completing the form. Unfinished hands can have meaning in nude painting. Keep in mind that the fingers are minor details in comparison with the rest of the body. For a naturalist painter, dedicated to a painstakingly detailed description of reality, this would not be an excuse for leaving the hands unfinished. But in carrying out sketches and quick drawings, or in media such as pastel or watercolors, as well as in Impressionism and other styles of great chromatic liberty, the key roles of color and volume expressed in few strokes make detail work subordinate. The meticulousness required to carry out the fingers in detail would break the stylistic coherence.

MORE ON THIS SUBJECT

• Basic Anatomy 1: The Bones **p. 22**
• The Hands **p. 34**

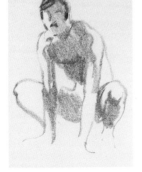

In sketches like this one, there is hardly any reason to indicate the position of the wrists and ankles in order to represent the position of the hands and the feet. Only through practice and experience can the artist attain this degree of synthesis.

The Firmness of the Feet

A frequent error in drawings of standing figures is that they do not give the impression of firmly standing on the ground. Instead, they seem to be floating or unbalanced. This is an error in drawing that is easily amended by intensifying straight lines along the sole of the foot and reducing curves to a minimum. In any case, the nude should always be firmly standing on its feet, unless the pose requires otherwise.

FORESHORTENING

Foreshortening is the name of the technique used to represent perspective in the human figure or one of its parts. The art of foreshortening consists of representing the parts of the human body from points of view in which the dimensions become shorter due to perspective. But we are not dealing with the usual science of perspective. There is no need for vanishing points nor other methods used in linear perspective.

What Is Foreshortening?

It is not the same to see a figure from the front as it is to see it reclining. In the latter position, the figure appears shorter due to perspective. One of the most famous works with foreshortening in the history of art is *Christ Dead*, a work by the Italian Renaissance painter Andrea Mantegna. This painting shows a figure lying in a foreshortened position such that all of the dimensions are distorted. Yet, the realistic sensation is absolute. In the great majority of cases, the view of a figure normally includes one or several parts that must be represented using foreshortening—an arm or leg extended toward us, a hand or foot whose toes are perpendicular from our point of view. These

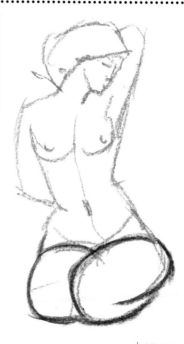

Foreshortening allows subjects as harmonious as the one illustrated here to be represented. Seen from the front, the thighs and calves create a series of curves that fit inside of each other. Foreshortening by Jordi Segú.

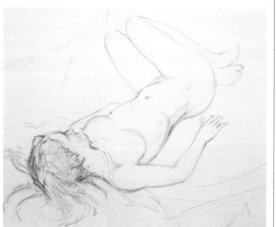

This example by Joan Raset perfectly illustrates the technique and art of foreshortening. The apparent deformations produced by foreshortening can be the subject of artistic creation and harmony.

are examples of foreshortening. To represent foreshortening, one must be familiar with the proportions of the figure previously explained. With these proportions in mind, it is easier to interpret the shortened forms without making errors or undue distortion. Nevertheless, it is just as important as this knowledge to pay close attention to what one is seeing when studying a pose, and to faithfully represent all the peculiarities one sees for the results to be realistic.

Poses and Foreshortening

A foreshortened figure is a figure seen in perspective, a figure whose proportions

The Dynamism of Foreshortening

Foreshortening is an exceptional means of representing the movement, energy, and drama derived from the human body. Great masters interpreted it thus in representing figures from the most varied points of view and in the most dynamic poses. The golden era of foreshortening in the history of art is the Baroque period. The great decorators of palaces constantly used the resource of foreshortening to create spectacular effects, such that figures appear to be rising or falling.

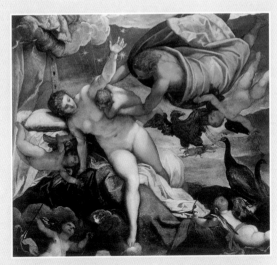

Tintoretto, The Milky Way. *The National Gallery, London.*

appear to be deformed due to the point of view from which they have been painted. Foreshortening is one of the technical problems inherent in learning how to draw or paint a figure. In addition to its academic interest, it can be an excellent artistic means if used consciously, with a specific end, and especially in a natural way. A good amount of the poses that an artist represents contain foreshortening. But there are some parts of the body that become especially interesting when represented in foreshortening perspective. The artist who is conscious of this has new criteria for choosing the most appropriate pose with regards to the aim.

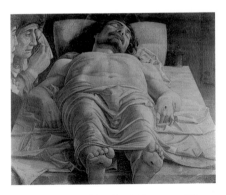

Andrea Mantegna, Christ Dead. *Pinacoteca di Brera, Milan. This is the most famous foreshortening of the Renaissance and one of the key works in the evolution of forms representing the nude.*

The Body in Foreshortened Perspective

Carrying out the entire body of a model in foreshortened perspective is always a stimulating exercise. It is stimulating because one must rely almost wholly on one's capacity for observation to represent the forms that really appear in view. An experienced figure painter knows the anatomical forms by memory, as well as the way they fit together and their possibilities in other, more common poses. But with a model in an odd perspective, all of these forms become distorted by foreshortening, and the artist must be governed by what the eye sees and ignore the information stored in memory in order to faithfully represent foreshort-ened dimensions in such cases.

The most common pose for the foreshortened perspective is a reclining position as seen from a slightly elevated point of view. Here, the dimensions of closer parts appear much larger than those farther away. These distortions must be transferred to the canvas without corrections to deformations, as these are what lend significance and interest to this type of pose.

LIGHTING THE NUDE

Light is an inseparable factor of form: a shape can only be visible by the effect of light.
But light also affects the volume of the nude, creating a characteristic drawing and a series
of limits between the light and dark zones that heighten the purely anatomical profile.
Creator of volume as well as foreign effects, light is an indispensable aspect in artistic
representation of the nude.

The Direction of Light

The nude can be illumi-
nated from above, from the
side, from behind, or from the
front. With frontal illumination,
shadows almost disappear, the
volume and sense of depth are
minimized, and the color of the
skin itself is displayed in all its
glory. By moving the light to
the side of the model, the
shadows emerge, creating
relief in the volumes, and the
form is clearly defined.

In a completely lateral
position, the light leaves the
opposite side of the model in
shadow, and the volume and
relief accentuate the shadows
cast. Viewed with backlight-
ing, the shapes of the nude
present a characteristic halo
effect around the contours, and
the volumes take on a weight-
less appearance. When the
figure is lighted from above
with zenithal lighting, the
shadows cancel out the effect

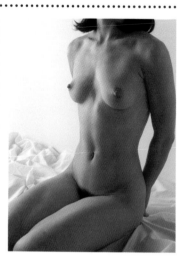

*Under lateral lighting
the shadows do not
entirely cover the
forms and the
volume of the
torso. There exists
a subtlety in the
transition from light
to shadow that
requires a
progressive work
of values, that is,
toning with
different
intensities.*

of relief and create a somewhat
phantasmagoric appearance,
similar also to the illumination
directed from below (very
rarely used).

Among all these possibilities,
it is recommendable to choose
the least extreme types (slight-

ly lateral lighting), as they
bring out the volumes without
producing distortion, although
it is always worth trying out
new possibilities.

Drawing Shadows

The shadows cast over a
nude are what create the real
drawing: a series of indepen-
dent outlines of the anatomy
lend a hint of drama to the
representation. Once all as-
pects of anatomic relief have
been understood and mastered
through practice, the artist
should study them under
different lighting conditions,
since the nude never appears
in its entirety. Regardless of
whether it is natural or arti-
ficial, light always affects the
configuration of its form.

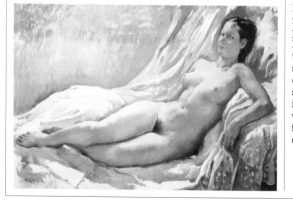

*Josep Puigdengolas, Nude. Museo de Arte Moderno, Barcelona.
An example of lateral and diffuse lighting that brings out the
softness of the anatomy.*

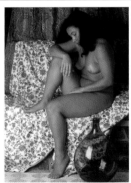

These photographs have been taken by moving the spotlight around the model. Here we can see the result of placing the light in a frontal-lateral position (shining from left to right) in which the model and the other objects are equally shaded.

Interplay of Highlights and Shadows

As important as the effect of direct light on the figure is that of reflections of light and of shadows cast. These are constant features in reality; all objects are affected by highlights and shadows that alter their color. The same can be said of the figure; drawing it under a single spotlight is an artificial technique. The colors surrounding the nude cast their shadows and reflections over it; light creates unexpected harmonies and effects, which are reflected on the surfaces of objects, emitting highlights from a variety of points and creating shadows that alter the continuity of the lighted forms. This may at first appear to be an inconvenience, but it can be turned into an advantage if we interpret these interplays of light freely and are daring in our interpretation of the highlights and shadows, searching for variety and dynamism of the form.

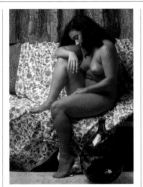

Superior lateral lighting (more dramatic than the previous type) darkens the foreground and highlights the area of the head and the hand.

Searching for Light

The artist can create a wealth of reflections and shadows by surrounding the figure with elements that produce tones over the skin. Light reflected on white fabric lightens the shadows; if the fabric is red, the shadows acquire this color and shade the body with said tone. Likewise, if an object is placed in the path of the

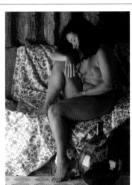

Lighting from below lends a theatrical solemnity to the scene and fades out a large portion of the figure.

light, its shadow will be cast over the nude, creating an effect that can acquire a highly interesting pictorial quality.

MORE ON THIS SUBJECT

• Value and Modeling **p. 42**
• Value and Color **p. 64**
• The Nude with Values and the Colorist Nude **p. 66**

Chiaroscuro

Chiaroscuro is the most dramatic form of lighting. It consists of directing an intense light source that divides the anatomy of the model into specific zones, those in total light and those in virtual darkness, which can be confused with the background. This effect was popular with the painters of the Baroque, who used it to heighten the drama and spiritual expression of their nudes.

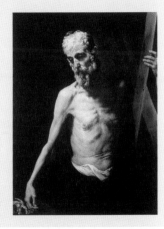

José de Ribera, San Andrés. *The Prado, Madrid.*

VALUE AND MODELING

Value refers to the way in which the model's shape is constructed by means of gradations of a single tone (the gray of a lead pencil, the black of charcoal, or any color of the palette). The value of the drawing leads to the modeling of the nude, that is, the creation of volume, the curves of the human anatomy. These two concepts, value and modeling, form the fundamental basis for drawing a nude in its entirety.

Value

When referring to the notion of value, one must forget color and concentrate instead on black, white, and gray. By starting out with a monochromatic gradation we can define the values as tones, or, better said, the different intensities in which tones are presented. Each discernible intensity of gray in the mono-chromatic gradation that ex-tends from black to white is a *value*. In this case, the values are gray. In fact, the artist can obtain values of any color, such as red, green or blue. The values of a color allow us to represent light and shadow according to how we increase

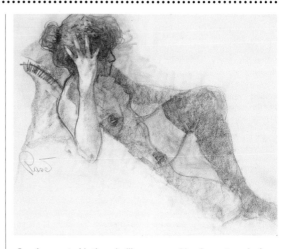

A nude executed in the grisaille manner, with only one tone, by Joan Raset. The entire body has been worked with a dark value from which a light value of the arm emerges.

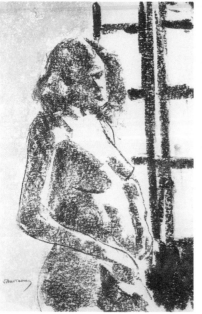

Ramon Sanvisens, Figure. Private collection. This drawing has been done by means of an energetic contrast of extreme values of black and white; few values and a striking effect of lighting.

or lessen the intensity of the chosen color. A good example of this can be found by studying a drawing executed in the grisaille manner (using only tones of gray) or by looking at a black-and-white photograph. When painters draw a figure in grisaille, they forget about color. To work in chiaroscuro is to use values of light and shadow, drawing step by step from the brightest highlight to the darkest shad-ow through a series of grays. This type of gradation must be extensive enough to bring out the transition of tones with subtlety and without stark contrasts.

What Is Modeling?

Modeling is a direct con-sequence of obtaining the

correct values of the lights and shadows over the figure's body. Modeling may make us think of clay sculpture, the task of obtaining a three-dimensional form.

The type of work required to draw a figure in chiaroscuro is not so different: the more intense the chiaroscuro, the greater the contrast should be between the light and dark areas; the greater the sensation of volume obtained, the more evident the effect of the light on the figure.

Likewise, the greater the contrast between light and shadow, the greater number of intermediate values required to ensure the surface continuity of the form. This rule is also applicable to the nude's volumes, which are curvilinear and demand a subtle and gradual transition from the lightest highlight to darkest shadow. The modeling technique is very popular among artists who aspire to a sculptural dimension of the nude, that almost tactile sensation of well-rounded forms within a space in depth in the representation.

Modeling Techniques

Modeling can be achieved with all manner of drawing and painting media, provided only one color or a very limited range of tones is used. The use of various colors becomes a question of color contrasts more than of values (or grays or tones of the same color). The grisaille, therefore, is the universal technique for modeling the nude.

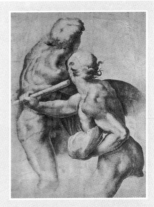

Michelangelo, Two Male Torsos Viewed From Behind. Academy Museum, Venice.

Value and Modeling

Even though they appear to be similar concepts, value and modeling are not exactly the same. Modeling also consists of creating an enclosed and uniform volume, but it is possible to obtain a form through values without a complete modeling. By contrasting one tone with another (for example, the tone of the figure with the tone of the background) the artist may execute the work through values but without necessarily modeling it. The values can be done with flat colors that create a contrast of the two to a greater or lesser degree; when various contrasts are extended over the paper, we can say that the composition is obtained without the use of modeled volumes. Therefore, the effect of light and shadow can be attained without a complete modeling of the figure's forms, but rather by introducing the necessary contrasts in order to achieve this effect visually.

As a general rule, there is no need to obtain too many contrasts of value to create depth in a painting. A drawing or painting may convey relief without the inclusion of much modeling. However, without the existence of values, the nude will appear completely flat.

This figure by Joan Raset was modeled with numerous values, or many different degrees of light and shadow. From the white of the paper of the brightest zones (shoulder, thigh, knee), to the maximum shadow, in the space between the arm and the hip, the figure is treated with a wide range of tones that envelop the body's volume.

TECHNIQUE AND PRACTICE

BLOCKING IN AND COMPOSITION OF THE NUDE

The blocking in and the composition of the nude must be based on the particularities of the anatomy. The artist must take into account the model's proportions, and the relative size of the head with respect to the rest of the body and the limbs. At the same time, these proportions must fit harmoniously within the confines of the paper or canvas in order for it to appear natural.

· ·

Blocking In

To obtain a general outline of the nude, we must learn how to block in all types of poses. With sufficient knowledge of this technique, it is possible to represent any pose, no matter how complicated, from the outset of the work; that is, the elements that comprise the pose must be unitary and correctly proportioned. Blocking in includes calculating the proportions, which must be conveyed schematically in order to obtain a simplified view of the correct proportions.

Every pose can be reduced to a general outline with a few sketch lines. Indeed, it can even be reduced to a single continuous line, although such a solution is not necessary. The basic shape must be simple, an oval, a polyhedron, a pyramidal shape, and so on—one that best describes the posi-

This nude can be blocked in using a number of different sized triangles; the proportion of the shape must allow the entire pose to fit within it.

tions of the limbs. This basic geometric outline allows the rest of the figure to be drawn in with ease.

It is not necessary to attempt

to include details nor concern oneself with the intricate work of modeling. The artist must aim only for the basic form, the figure's general structure prior

The blocking in of this figure (by Muntsa Calbó) begins with the sketching of one or several basic geometric forms that can enclose the nude and are proportioned to it.

By correctly blocking in the subject, Muntsa Calbó has ensured that the sketch will turn out successfully. The artist works resolutely, confident that there will be no deformities or incorrect proportions.

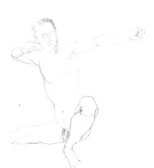

Value and Modeling
Blocking In and Composition of the Nude
Drawing Media and the Shading Procedure
45

to the definitive drawing. This basic guideline provides the position and size of each one of the parts. By starting in this way, we can obtain the general contours by means of strokes.

A Question of Synthesis

If the angles of the outline are rounded slightly and some of them are given more intensity, the volumes of the body will begin to emerge without the need to study them separately. That is what is meant by synthesis: looking at the drawing as an articulated whole whose parts can be developed simultaneously, without any particular one taking on more relevance than another. In the basic lines of this type of sketch, the artist must concentrate only on the essence of the synthesis; the

lines may be unfinished but they already establish the pose and the sizes of the figure's arms and legs. Each one of the geometric shapes must comply to the characteristics of the pose: the development of the sketch is merely a logical consequence of the initial outline.

Developing the Nude

Artists use the blocking in procedure to serve their artistic aims. When the aim is a shaded drawing (which is often the case), once the model has been blocked in and the contours have been drawn in, all that remains is to soften the transitions from light to shadow, bearing in mind that anatomy is a uniform continuity, without abrupt transitions, so that the limbs

Blocking In and Shadows

With common sense and a little knowledge of anatomy, it is possible to model a body with just a few shaded areas. Volume depends both on the line and on the shadows, but it is the correct forming of the shadows that really brings out anatomical relief with greatest effect. A correctly adjusted modeling is the orderly way to understand a figure as a unitary whole.

appear natural. The drawing is no more than a blocked-in schematic outline taken to its limits, that is, until the form has been defined with all its highlights and shadows.

The figure is then shaded, without pausing to work on details, searching out the key areas of shadow cast over the body that lend it volume.

Regardless of how complicated a pose may appear to be, it can always be blocked in using a simple geometric shape.

The previous work of blocking in this pose has led to a perfectly articulated nude, drawn by Muntsa Calbó.

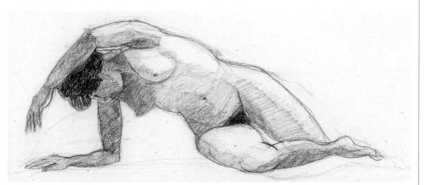

DRAWING MEDIA AND THE SHADING PROCEDURE

The value and modeling of the nude are obtained by shading. It is far easier to study the shading procedure in a drawing than in a painting, as the variations of shadows or values are alterations of a single tone and colors are not used in the work.

Light, Shadow, and Reflections

In standard, moderate lighting conditions that illuminate the figure down one of its sides, the anatomy of the nude is affected by a series of highlights and shadows. In the first place, direct illumination lightens the body, and it is in this or these zones that the brightest values must be situated (often by the white of the paper itself). The shadows come next by means of progressive gradations or through resolute contrasts against the lighter zones. In addition to the fundamental light and dark zones, there are often reflections in parts of the figure in shadow: areas slightly illuminated by the reflection of a light on the surfaces surrounding the figure. The reflections are never as dark as the darkest shadows, and their tone lies halfway between these and the brightest parts.

Grisaille

The grisaille technique consists of executing the drawing through a number of different values or intensities of a single tone or color. In order to find a variety and wealth of values in the nude, one must play with the lighting.

The most suitable lighting for this type of exercise is lateral illumination, because it produces the shadows that best bring out the volumes of the model. To draw a picture in grisaille in order to learn about the values of light, shadow, and reflections, the artist must think in black and white and a range of gray tones (or subtle intensities of the chosen tone) and completely forget about color. The grisaille requires lightness and agility when shading. Its execution must be done fast and without stopping to work on details.

The tip of a dirty piece of charcoal or pastel makes a fine drawing instrument for the first stages of the shading of this work by Joan Raset.

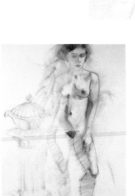

The shading process proceeds from less to more, from the subtlest of shadows to the most intense ones.

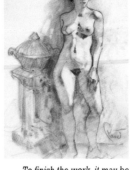

To finish the work, it may be necessary to go over a line or two in order to bring out the entire form of the somewhat faded outline after the shading work has been completed.

Process

The work begins with a preliminary drawing in pencil or any other drawing media. The drawing should be very basic, linear without exaggerating the intensity of the line. This is only a drawing to situate the model, that is, the model will be blocked in within the format. The softness of the stroke is paramount,

Blocking In and Composition of the Figure
Drawing Media and the Shading Procedure
The Sketch

47

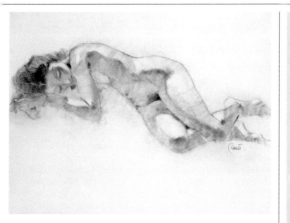

In this drawing by Joan Raset, three major areas of light and shadow can be discerned in the shading: the maximum highlight (the thigh), the darkest area (the shadow cast over the hip), and the reflection (the tone of the breast and the stomach).

because in a grisaille drawing the contours always comply with the highlights and shadow, and so the line should not appear too prominent. In fact, it is the interplay of values that brings out the form and the contours of the figure. If necessary, errors can be erased or rectified prior to shading in.

Transition Between Shadows

The transition between shadows (from light to dark or vice versa) must be carried out in accordance with the medium being used. With pencil, such transitions are obtained by applying pressure on the implement and accumulating series of strokes to darken the shadow; with charcoal, the darkening process is carried out by intensifying the charcoal application, and the transitions are achieved by stumping or blending the area; the process used with chalk or pastel is similar to that of charcoal. The stumping pencil can also be used to obtain the desired effects.

Choice of Tone of the Grisaille

In a shading exercise to obtain a correct modeling of the nude, in which only a single color is to be used, the artist must choose the one that offers the best tonal possibilities. The tone must be dark enough to obtain a broad range of values up to the lightest. Certain blues, such as Prussian blue, produce highly energetic and striking shading. Dark greens are more difficult to work with and may appear somewhat artificial when used in drawings of the human figure. Dark earth tones are easy to work with and offer a visually harmonious result.

MORE ON THIS SUBJECT

- Lighting the Model, **p. 40**
- Value and Modeling, **p. 42**
- The Sketch, **p. 48**

Working with pencil, it is important to begin shading with soft strokes.

With pencil, the shadows are achieved by applying pressure on the implement and superimposing lines, as can be seen in this drawing by Muntsa Calbó.

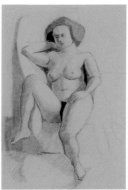

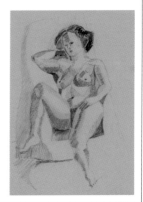

THE SKETCH

A fast sketch is the foundation of the study of the human figure. Every work begins with one or several sketches. The sketch may comprise the beginning of a definitive work or merely act as a groundwork. Whatever the case, the sketch plays an indispensable role because it forms the basic structure of the work the artist wishes to execute.

From the Idea to the Paper

The aim of the sketch is to bring together all the features of the naked figure. Certain creators are gifted with the capacity to capture all the characteristics of a pose at a glance and transfer them directly to paper. Most of us, however, end up with a rough sketch, a basic outline that we can use when the opportunity of drawing the pose from nature arises. A good sketch of the nude requires an enormous capacity of synthesis of the factors that comprise the drawing of a figure: blocking in, the proportions, line, and shadow. When sketching a motif, the artist should not concentrate too much on these aspects, but the result must be a complete whole, satisfactory in itself, which includes all the necessary elements in order to understand the pose and the anatomy of the model. A work of this type of synthesis allows the artist to further develop the work or, if the artist so desires, it can be left at the sketch stage. In addition, good synthesis allows the sketches drawn of a model to be finished off in the studio without the need of the model's presence.

Format of the Paper

In order for a sketch to have the potential of becoming a full-fledged work, the relationship between the figure and the format of the paper must be dynamic. Such dynamism does not mean the figure must appear to be moving: a pose may be static while at the same time situated on a sheet of paper whose format fits the size of the model and thus makes it appear more dynamic. Other possibilities of lending dynamism can be exploited by situating the main masses of the figure close to the edges of the support, balancing the whole by means of the position of the limbs or by shaded areas that convey the elements of the surroundings. In any case, every pose has its own particular problem and requires resolving through a different compositional balance. Furthermore, a single pose can be tackled in a variety of settings, depending on how the artist's point of view increases or diminishes the figure on the paper.

Two perfect examples of sketches done by Vicenç Ballestar, in which the line and the shading combine to create perfect expressive synthesis, with the indispensable anatomical details of the nude's pose.

The Rhythm of the Line

An important aspect of the sketch is the rhythm of the line. Rhythm is an artistic concept borrowed from the world of music. Just as in music, in drawing the line is marked by the alternation of accents and "silences" or neutral parts. The distribution of these alternations determines the attractiveness and interest of the rhythm. The accents of a drawing are alternations within continuity: a diagonal line that breaks into a vertical line or vice versa. An accent is therefore a linear continuation that breaks with this tendency. We can find poses with and without rhythm. A pose with rhythm can be described as one that expresses a harmonic dynamism, composed of dynamic alternations. A static figure in an erect position is the antithesis of rhythm.

Shading the Sketch

The sketch should always be shaded lightly; it should

The Importance of Synthesis

The capacity of synthesis is essential in all forms of art. It means to encapsulate the important part of the form, the part that possesses intrinsic plastic and pictorial value, that which conveys the presence and attitude of the figure. The capacity of synthesis is immensely practical for figure artists because it enables them to draw a figure as if caught spontaneously. A figure or a basic outline of one must contain all the information necessary for the spectator to recognize the different actions and gestures of a figure, capturing the "moment of grace."

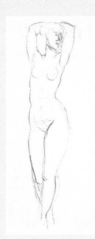

A few strokes are enough to define and articulate the anatomy of this nude drawn by Muntsa Calbó.

never be overwhelmed. It all boils down to searching for synthesis of lights and shadows, a synthesis that constructs the figure with the essential elements. Unskillful artists tend to overdo the work of shading and consequently make the

In this other sketch, Muntsa Calbó has captured with manifest precision the foreshortening of the figure; the drawing contains all the information necessary to interpret the movement of the nude.

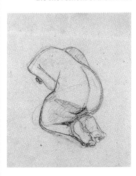

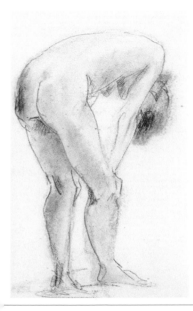

The anatomical correction is implicitly present in this sketch by Muntsa Calbó. The synthesis of the form is created by the agility of the line and spontaneity of the shaded area.

drawings appear confusing. In large-size works it is also important to begin with a basic synthesis of shadows, and then gradually work one's way toward the parts of greater complexity, but never start with detail or try to complete the entire figure with the same meticulousness.

SKETCHES AND DRAWING MEDIA

There is no better way to practice figure drawing than by executing fast sketches that can be used to obtain partial aspects of a pose. Although they may only be rough linear sketches, without any artistic aim, they are very useful. It is often the case that these almost automatic sketch lines, executed spontaneously, suggest completely new possibilities for the artist.

Various Media

The implements used for sketching must be light and easy to carry around. When working with lead pencil, the best solution is to use an automatic pencil: it sharpens itself with use and lines and patches can be applied with the side of the lead more easily than with a pencil.

When sketching it is recommended that you use an automatic pencil with soft leads of medium thickness. In addition to graphite pencil, Conté sticks and charcoal are excellent drawing tools for sketching. But by far the most

From the simplest lead pencil to the nib, to charcoal or chalk, drawing media make sketching easier.

Sketch executed by Joan Raset with two tones (pink and red) in pastel. Pastel is a drawing medium that can be extended to the domain of painting with the addition of a wide range of colors.

Sketch drawn with a nib and ink by Muntsa Calbó. The nib obliges the artist to conceive the nude mainly through lines.

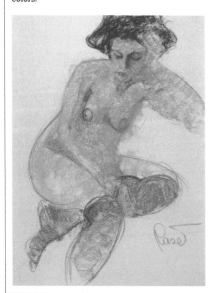

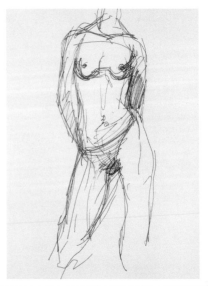

attractive for this type of work is the nib or fountain pen. Drawing executed with this medium convey all the lightness and spontaneity of the moment: the nib is precise in detail and harmonious in the free stroke; it does not need to be sharpened and its utilization is similar to fast hand writing.

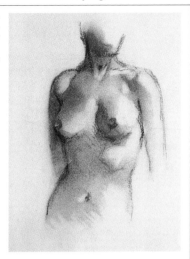

Sketch by Vicenç Ballestar; the artist has used Conté and sepia-colored chalk, two classic tones for drawing the nude.

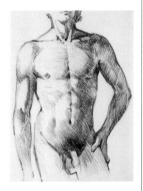

Sketch in charcoal by Vicenç Ballestar.

Lightness of the Line

There are two types of exercise to practice drawing interesting lines in sketches: working with a fine implement (such as a nib or a ballpoint pen), or with a thicker tip (a felt-tip pen or a stick of charcoal). In the first case, the artist must work quickly without taking the pencil tip off the surface of the paper, without shading, only following the shape's continuous line or a series of discontinuous lines that express form. In the latter case, the question is to represent the figure by means of a few strokes that display the general layout of the highlights and shadows.

Both procedures require different attitudes and the artist should adopt one or the other according to his or her personality. Another technique is to first attempt the subject without calculations or looking at the paper. Although this method may sound unusual, many artists use this exercise in order to avoid having to retouch the form.

Elementary Media

One of the secrets to developing the required capacity of synthesis is to work with very rudimentary media. No sophistication or high-quality materials: pencil and paper, or charcoal, or brush and ink, or even ballpoint pen. The most elementary of materials always demand the artist to concentrate on the most basic aspects and forget about details. Working from nature with these media compels the artist to search out the most essential aspects of the scene without concern for secondary items.

The most rudimentary of media are those that allow the artist direct expression.

MORE ON THIS SUBJECT

• Drawing Media and the Shading Procedure **p. 46**
• The Sketch **p. 48**

STUDYING THE NUDE

The studying of poses and compositions, for form and color, through sketches should be a spontaneous and everyday activity for the artist. No special preparation is required; any pose will do. The pose of the nude can be captured with several quick strokes, a contour or even by means of successive outlines and compositional sketches; it can also be done with shaded patches, detailed sketches, groupings, touches of color executed with different techniques, and so on.

Studying the Figure

The study of the figure is the basis of all artistic practice. The reason that all art teaching is based on studies and sketches is because the figure entails every possible aspect of form and color. More profound studies are required in the case of the nude. No one, not even the most experienced painter, can say that he knows everything about the human body and has exhausted all its possibilities. There are always new solutions to try, new discoveries to be made. The study of the nude is based on drawing all manner of sketches: in black and white or in color, on small-sized paper and on large. Only through the work of sketches can the painter understand forms and attempt new combinations of composition

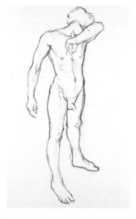

A study of a movement drawn in pencil by Miquel Ferrón. Sketches of movement must be executed with speed.

and color. Such sketches can be drawn of the entire figure or merely fragments of it, or they can be drawn prior to the

There is no other way to study poses than by drawing spontaneous and simple sketches in pencil, charcoal, or any other suitable drawing medium like this used by Miquel Ferrón.

execution of the definitive work or during the process.

Fast Sketches

Always keep a drawing pad of some sort on hand or several loose small sheets of paper for drawing quick sketches in order to get down a difficult twisted shape, a doubt about a back movement, the capturing of an instant movement. Although such sketches may only comprise several free strokes, with little artistic merit, they may be very valuable. Often those few lines drawn on the spur of the moment and almost without thinking about it suggest new possibilities for the artist. Never throw your sketches away (at least not for a reasonable amount of time and only when you are convinced they do not serve any purpose).

The best way to study the nude is by painting or drawing it from nature, but artists can also use photographs or reproductions of drawings and paintings by their favorite painters.

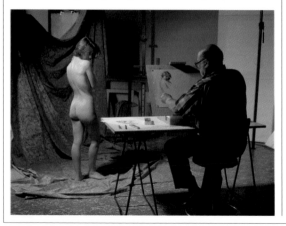

An exercise of highlights and shadows drawn by Joan Raset in which the main aim is the study of the anatomy of the back and the legs that are illuminated. The result may lead to a painting, given that the chiaroscuro is completely resolved.

Studying Movement

Delacroix said that a good draftsman is capable of capturing the movement of a body falling from a fifth-story building. Perhaps the great French painter exaggerated somewhat, but the main idea of his remark is true; the greater the painter's capacity for representing instantaneous movement, the greater his capacity for representing the immobile figure. Drawing movement is a question of understanding the flexion and extension involved in it—the flexion and extension that belong to the pose itself. A good way to study poses is by making a series of quick sketches (between 20 and 30 seconds in duration) with the fewest possible strokes, only those that are indispensable to visually express the pose. A further step is to ask the model to move his or her body slowly while you draw "snapshots" of the movements. In the event of not having a model at hand, the artist can always resort to photographs.

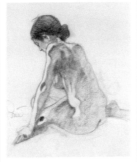

A sketch can be completed with several patches of color. Occasionally the sketch becomes complicated and the artist, without wanting to, draws a work that goes beyond the mere compositional study.

Another drawing exercise, drawn spontaneously by Joan Raset: one compositional study among many that can be drawn of this single pose and that does not require an in-depth study of anatomy or light.

MORE ON THIS SUBJECT
• The Point of View and the Pose, **p. 54**
• Pose and Movement, **p. 56**

Studying Composition

Sketches to study composition are another indispensable complement for the artist's work. In this type of sketch the artist should be concerned less with anatomy or movement of the nude and more with its position within the confines of the support. This type of work can be done with a few simple straight and curved lines to block the figure in and distribute its volumes over the paper. There is no need to fill out several sheets of paper to practice the composition before starting the definitive work. By drawing a frame of similar proportions to the format of the work you can solve the problem in one or two strokes.

TECHNIQUE AND PRACTICE

THE POINT OF VIEW AND THE POSE

Drawing or painting a nude from in front, from the side, or from behind is as much a technical and stylistic decision as a psychological one. Technically, each type of pose requires different solutions, with a greater or lesser amount of drawing work, of color or chiaroscuro. From a psychological (or thematic) point of view, the suggestions implicit in each one of these poses are different.

Nude Facing the Artist

Painting the nude from in front implies personalizing it, that is, turning it into a concrete person rather than merely a generic model. Therefore, poses of this nature are more akin to the idea of a portrait. Although the aim may not necessarily be to paint a portrait, the nude seen from this point of view forces the artist to take the face into account, and this means it has to be given a personality.

Regarding the technical aspects entailed in frontal poses, it is important to point out that certain difficulties arise with respect to volume. In effect, both the figure's head and the trunk when seen from the front can be captured in a simple drawing, but this leaves the internal volumes undone. These inner volumes can be drawn by means of light and dark tonal values.

This is a very general guideline, but it can be used to channel the interest and choice of pose, bearing in mind that in order to elaborate the frontal nude, one has to concentrate on volume and its values of light and shadow.

The outline is not enough to express the nude in a frontal pose. A work of highlighting and shading is required to represent the figure's volumes that cannot be expressed with lines.

This work by Joan Raset is based on the two sketches included on this page and displays the internal volumes, coloring, and modeling, more than the contour, in a frontal nude.

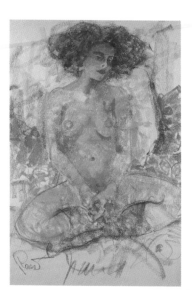

Nude Seen from the Side

The drawing of a nude from the profile point of view can almost be defined as exactly the opposite of the frontal pose. In the profile pose it is the outline that is important: the shape of the head, the facial features, the shoulders, the trunk, the stomach, the muscles, and everything else that can be represented with a continuous line. This does not mean that the volume and modeling lack importance in these poses, instead they are subordinate to the lines. If the line is dynamic, it may contain enough visual interest so that only a few shaded areas need

Two outlines that display the relatively little importance of additional information that we can include in a figure in profile, apart from the linear contour description.

The Pose and the Artist's Aim

Before drawing a nude, it is important to consider which aspects artists wish to concentrate on in their work: the line, shading, color, chiaroscuro, movement, and so on. Certain poses permit some of these aspects better than others, as has already been mentioned on these pages. The use of photographs or art reproductions is a good way to try out the different possibilities each pose has to offer.

When viewed from the side, it is possible to bring out more detail with contours. The volumes manifest themselves without the need to emphasize the modeling. This painting by Joan Raset is the end product of the two outlines sketched above.

A work by Emilia Castañeda. The entire figure has been described through its outline; this is enough to define the form and volume.

be included.

Few figures are ever seen completely from the side. There are always parts of the whole that are facing forward or backward.

Nude Seen from Behind

The nude posed with its back to the painter, especially the female model, is a common

MORE ON THIS SUBJECT

• Studying the Nude **p. 52**
• Pose and Movement **p. 56**

subject in this genre. The great painter Edgar Degas painted some wonderful works in pastel from this point of view. All of them convey the effect of a figure being observed by a spectator without the model's knowing. This natural impression marks the most interesting psychological interest in this type of pose. Indeed, the model is not posing, but rather appears to be observed and painted without her knowledge.

Technically, the execution of a back, be it male or female, becomes an interesting subject matter in itself. With good lateral illumination, one can achieve a good pattern of highlights and shadows. The artist should take time to observe the phenomenon in order to obtain a correct construction of the back.

POSE AND MOVEMENT

Despite the fact that all pictorial representations are static, many poses suggest or imply movement. The position of the legs and arms may be static or dynamic; the pose can be open or closed. These are important considerations when choosing the type of pose, regardless of whether the artist is working from nature or from reproductions.

Set of Harmonic Parts

If we consider the nude as a whole made up of harmonic parts (exactly as the artist should see the nude), an open pose is that in which certain parts are represented more individually with respect to the whole. A closed pose is one in which the whole overshadows the individual parts. Applied to the field of painting and drawing, the closed pose is that which can be outlined within an enclosed regular or irregular form (an oval, a rectangle) to express the body as a single mass without protruding elements. The sketching of an open pose requires more elements, more figures, in order to situate the position of the limbs.

The Closed Pose

In the closed pose, the whole dominates the parts. The best example of this pose is a nude curled up at rest with the legs curled up into the chest and the knees bent. This basic idea of a closed pose includes all imaginable variations of this. In addition, in the case of the female nude, there exists a constant feature of these poses that is always interesting from an artistic point of view. We are referring to the harmonious transition that tends to occur from the shoulders, down the back, to the thighs of the figure; an uninterrupted continuity that describes the female figure in all its grace. The closed pose with the figure standing up is not as

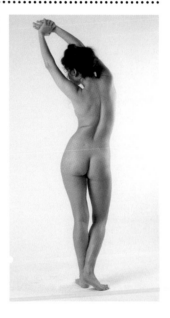

Example of open pose: the anatomic form is extended, or deployed.

common as the one we have just examined (at rest) but does deserve a mention. In fact, the pose is not as closed as the former, given that the nude is vertically positioned, but it continues to be a closed form (a form that could be a column) from which there are barely any protrusions. In such poses great care must be taken with the harmonic contour line, because all interest in these poses is dependent on it.

Open Pose

Open poses imply movement. An open pose always represents an action. The one issue that must be taken into account in this type of pose

(and in all poses in general) is that the movement must be justified, that is, the position of the legs and arms must be coherent with a concrete movement, and not simply a gesture invented by the artist and dictated to the model. If the movement appears coherent it is because it complies with a natural action of which the positions of the limbs are logical consequences.

Movement and Gesture

Explicit movement can be defined here as one that the artist captures in the exact moment the movement is happening, neither before nor after. Therefore, the artist instructs the model to adopt a

Both movement and the expressive gesture of this figure have been captured in this painting by Domingo Álvarez.

more directly linked to a person's idiosyncrasy. To capture these gestures is also to capture movement, but in a far subtler way. In the work reproduced here the gesture merely comprises the displacement of the head; capturing these subtleties is important if the work is to transcend a mere anatomical exercise or academic correction.

frozen movement for as long as it takes to get down on paper. It is important that the movement in question respond to a natural gesture, otherwise the artificiality or falseness of the movement will immediately be evident to both the artist and the public. Sometimes we speak of a static pose as having movement. This apparent contradiction is due to the fact that the arms and legs reveal a previous movement by way of the twists and turns. The gesture can be described as the little brother of movement due to the fact that fewer muscles and joints intervene in the gesture. But

the gesture is much more meaningful and personal than movement. It is difficult to characterize a person purely through movement, even though it is possible to recognize someone, for instance by his or her walk. The gesture is

The Outline Before Anything

Be it static or dynamic, open or closed, the pose must begin with an outline or form that blocks in all its different parts. It does not matter how complicated the pose may appear to be, it is always possible to reduce it to a number of simple forms that summarize the articulation of the figure's arms and legs.

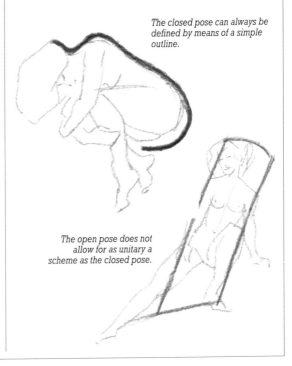

The closed pose can always be defined by means of a simple outline.

The open pose does not allow for as unitary a scheme as the closed pose.

BALANCE

The balance of the nude is important, because it lends stability and credibility to the representation. There is a simple way to control and check this aspect during the initial phases of the drawing, before moving on to a more detailed elaboration of the subject.

Pose and Balance

The concept of balance is simple: it refers to the stability of the figure, or its stance in order to prevent the sensation of falling either one way or the other. The matter of balance does not apply to poses in which the nude is lying or seated: the artist would have to be extremely clumsy to draw a figure in one of these poses and make it appear to be falling to one side. It is far easier to make this mistake when drawing the nude standing, especially in poses in which movement is to a greater or lesser extent brusque. It is important to avoid disorienting the figure or losing the horizon, thus creating an effect of imbalance. Surprisingly, poses in which the model is running or

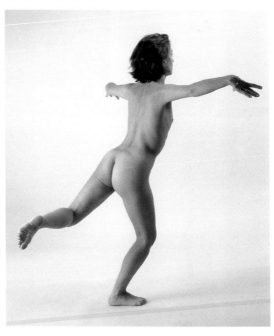

This pose is maintained in delicate equilibrium. The drawing must possess a similar balance.

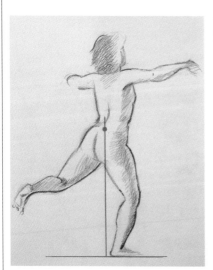

The line of gravity of the figure, drawn in red from the center of gravity (also marked in red), falls just off the foot that supports the pose: the figure therefore is off balance.

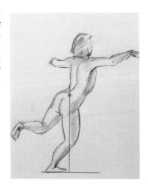

This pose is also off balance: it is falling forward, just as the line of gravity shows.

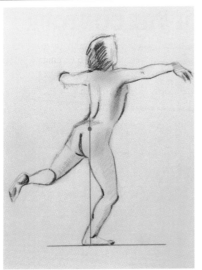

The balance of the nude can be checked by drawing a vertical line of gravity and ensuring that it crosses through the foot that is supporting the weight of the body.

Rough Guess

With experience in drawing nudes, the artist will be able to locate this point from the first line, correcting it while drawing without the need to calculate. In addition, a badly balanced model in movement can be compensated for by changing part or all of the movement the artist wanted to draw from the outset without losing the main feel of the work. Lastly, it is important to bear in mind that sometimes figures look off balance, even though the center and line of gravity indicate otherwise. In such (very exceptional) cases the visual effect should have the last word, for which reason the drawing will have to be retouched.

jumping are less likely to appear off balance, because the movement is of the snapshot type that does not expect any sort of balance.

The Center and the Line of Gravity

An effective method of checking the balance of a pose in a nude work is to locate its center of gravity. This center is normally situated in the area of the stomach of the figure standing up, and at the bottom of the spine in a nude seen from behind. All the artist has to do to check the stability of the figure is to locate the center and draw a vertical line from it. If the vertical line traverses the feet (both or one of them) supporting the pose, the figure is correctly balanced. If this is not the case, the representation will look off balance and the nude cannot be supported on foot.

Poses of running or jumping cannot be checked using this method, because the line of gravity is in mid-movement, although it would be useful to find it. It is not really necessary to draw the line of gravity

on the paper, but instead situate it and place a ruler (or the pencil itself) in a vertical position from the point where you have situated it.

Lack of Balance

Some artists deliberately draw their nudes off balance in order to lend them elegance to surprise the spectator. This is not a Classical method, given that Classical art is all about balance. Nonetheless, this simple technique allows artists to give their works a vitality and agility that is not possible to achieve through Classical means. It is worth mentioning that only when the technique of balancing the figure correctly has been mastered can the artist deliberately attempt to draw it off balance.

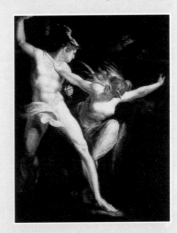

J.H. Fuseli, Satan and Death Separated by Destiny. *Neue Pinakothek, Munich.*

THE IMPORTANCE OF THE CONTOUR

When a work is drawn based on a contour, the credibility and expressiveness of the work depends on the execution of lines. The artist must understand the importance and artistic possibilities of these contours so as to prevent the line of the work from becoming a lifeless academic copy.

Descriptive Contour

Descriptive contours can be described as those whose only function and end in the drawing is to describe the outline of the form and volumes. They stylize the form. These strokes reflect to the greatest extent the artist's personal view, the essence of his or her style. Therefore what we define as descriptive contour here, are not only the lines used to

This anatomical fragment can be represented in a variety of ways. In the following sequence, David Sanmiguel demonstrates how to draw a picture based on a contour that can subsequently be heightened with some light shading.

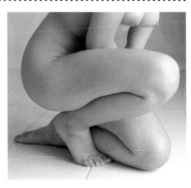

The task begins by drawing a form within which the model is to be blocked in—in this case a very simple triangle that facilitates a proportioned representation on the paper.

Having defined the initial outline of the scheme, the contour line defines all the volumes while at the same time lending an undulating rhythm in accordance with the spirit of the subject.

obtain an exact copy of the nude's outlines, as there are numerous ways of reproducing faithful copies of the human figure. The descriptive contour elaborates the genuine creations and arrangement of the anatomical form, creation that derives from the artist's sensitivity toward the form in question. These contours must possess an interest in themselves—personality and originality—the exact opposite of the academic drawing in which

If the contour is to be shaded in, the shadows must be very light so as not to overdo the description (of either the line or the shading).

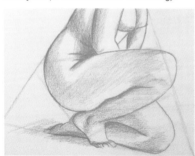

To bring the shading to an end, it is necessary to reduce the importance of the line considerably, otherwise there will be too much descriptive information.

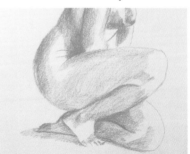

the artist merely seeks to create an exact copy.

The Line on the Paper

All artists are aware of the value of a stroke as an independent element. One simple way to test this theory is to take two sheets of paper and draw a quick sketch, using few lines, from memory of a figure on each one of them, without thinking. One will also be more appealing than the other; one will always have a line or group of lines that look more free-flowing, more lively and interesting than the others. This artistic virtue of the pure line has to be present in the drawing.

The interest of the nude's forms must be conveyed by means of the gracefulness of the lines of the drawing. This type of expression requires a certain amount of exaggeration, simplification or alterations that are completely legitimate, if they allow the visual quality of the final work to be heightened.

Decorative Strokes

In principal, all strokes, even the most descriptive, should possess a certain decorative component. Not decorative in the sense of gratuitous or affected, but in the noble sense of the word, that of embellishing or enriching the surface of the canvas or paper, that of possessing a value in itself as a rhythmic form combined with others. This may be so only sometimes, and normally it is a matter of limiting the decorative possibilities of the stroke to give functionality and descriptive sense to the form. The subject of the nude offers innumerable opportunities to allow one's imagination some free reign on decorative strokes. The model's hair, for example, is one such opportunity: the undulations of hair are perfect for free and imaginative strokes. Furthermore, the objects surrounding a figure may also be apt for this type of artistic flair. This can be achieved with flowers, for example, that can be evoked with color scribblings, the pattern of a chair, the movement of curtains, garden vegetation, and so on.

MORE ON THIS SUBJECT

• Studying the Nude **p. 52**
• The Point of View and the Pose **p. 54**

Intensity of the Contour

When the shape of the nude is based on contour, the line or brushstroke used to define the contour must be made finer or thicker according to the anatomy and also according to the lighting conditions.

A thick uniform line encloses the nude too coarsely, and does not express the incidents of light and shadow.

A fine line is appreciated as an illuminated part, while a thicker one is interpreted as a description of an area in shadow.

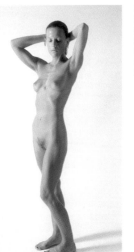

This figure can be drawn in its entirety with a number of contours of varying intensities.

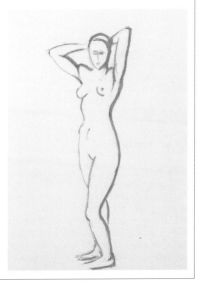

The finest lines of this drawing by Muntsa Calbó express the lighted areas of the figure, while the thicker ones provide the information on the distribution of the shadows.

TECHNIQUE AND PRACTICE

FROM THE DRAWING TO THE PAINTED NUDE

A good preliminary drawing before the painting contains hints of color that the artist must be able to notice. The distribution of the different zones and the relationship among them are factors that are achieved through the drawing and with which the color should be consequent. The different intensities of light and dark (in the drawing) can result in relationships of warm and cool, light and dark, blended and saturated colors.

Drawing and Erasing

When drawing a nude that is to end up as a painting, the artist's attitude towards the forms of the model is different from that of a drawing as an end in itself. In the preliminary drawing for a painting many questions will arise that will later be resolved through color in the painting. It is not necessary to resolve these problems in the drawing. Not only is it unnecessary, but it can prove to be a hindrance when you come to apply color. During the painting of the nude, the artist must have enough freedom to interpret the form with color. Often this interpretation can contradict the drawing, modify it or give way to a new, unforeseen version of the figure. Therefore, it is as important to draw as it is to erase when working on the idea you want to flesh out. The line must never be domineering; it must be left open to possibilities of color. The form should never be completely enclosed, unless the painter is totally convinced that the form is suitable for the color, which does not need any leeway.

Suggesting Form

One of the reasons that the preliminary drawing is so useful for the subsequent painting is that it only suggests form rather than explaining everything. To suggest the form means to respond rapidly and spontaneously to a view of the model and get the image down

In this pastel painting by Joan Raset, the step from the colored drawing is immediate: the strokes of colors draw and create the picture's color scheme at the same time.

on paper in exactly the same instant. Of course, this implies that the artist will have already taken the question of composition into account and blocked in the model correctly. In other words, the preliminary drawing must be worked out. Even if it is not, the painter can always rectify anything as the work progresses, superimposing lines that improve the form. Whatever the case, it is useless to attempt to finish the work with

the preliminary drawing and without taking into account the definitive colors.

The Colored Drawing

The colored drawing allows the artist to paint from the moment he or she begins the drawing. In effect, the monochrome drawing can be done with any color and with any media, (pastel, watercolor, oil),

The Importance of the Contour
From the Drawing to the Painted Nude
Value and Color

63

The following sketches of this female nude were drawn by Muntsa Calbó.

Harmony Between Drawing and Color

There must be a harmonic relation between the drawing and the color. Neither should diminish the other. This dialogue should dominate all phases of the painting, and in each one of them the artist must give preference to one or the other medium according to what best suits the situation.

and this color will determine the general color scheme. Black or any particularly intense color is not recommended. The best choice is a color that harmonizes with the model's skin color: carmine, sienna, mauve, and many others.

The Drawing with Color

The drawing does not automatically stop when the time comes to apply color, but rather it continues during the entire process. In pastel painting, for example, the drawing and the color blend to such a degree that in the finished work it is difficult to distinguish between one and the other: colored strokes paint and draw the model at the same time, the strokes are also fragments of color. This can be seen with total clarity in the less descriptive, less figurative parts. In these fragments the strokes create color and combine perfectly with the areas of color. Pastel is considered both a drawing and a painting medium. Watercolor also allows the strokes to form the lines of the drawing, just as oil does.

A pencil sketch in which the basic lines of the composition and several values of highlights and shadows are drawn in.

The colored pencil is a medium halfway between drawing and painting that allows the color scheme of the composition to be studied.

A new sketch, this time executed in watercolor, which sets out the composition and the colors in new terms.

VALUE AND COLOR

Value is not only important in drawing, it is also fundamental for the painting of a nude. Values may be variations of intensities of a single tone, or hues of different colors. Whether you are painting or drawing the nude, value must be used to construct its form.

Color Gradation

In the section on the value of highlights and shadows a monochromatic example of gradation was given. This technique becomes slightly more complicated when working exclusively with color, because it is one thing to distinguish between a light ochre and a dark one, and an entirely different matter to do the same between an ochre and a sienna or between an ochre and an orange tone. In the former case, the painter darkens a color, while in the latter, the painter juxtaposes two different colors. The result of these procedures is not the same either, since the juxtapositioning of colors lends a work a wealth of color, as well as achieving the effect of light and shadow, and some vol-

Drawing media like charcoal only allow the values to be dealt with, as we can see in this drawing by David Sanmiguel.

Work with color also implies assessing the values, as we can see in this work by Joan Raset. The values of the highlights and shadows have been interpreted through different colors rather than through intensities of a single tone.

ume. Of course, by painting with different colors, and not using different intensities of the same color, it is difficult to model or achieve the nude's volume: the result is less volumetric; but what is lost on the one hand (the chiaroscuro modeling) is made up for in terms of the great variety of hues and chromatic vibrations. In any event, there is also a close link between values and the colors of the nude. Knowing how to look at color and understanding value is indispensable.

Impressionist Color

The colorist interpretation of light and shadow and the volume of the forms of the nude is Impressionism's contribution to art. The Impressionist painters abandoned the chiaroscuro of academic painting to adopt instead a vibrant,

From the Drawing to the Painted Nude
Value and Color
The Nude with Values and the Colorist Nude

65

Ramon Sanvisens, Nude. *Private collection. This wash has been painted with light and color. Neither details nor a drawing are necessary. The body's volume is brought out through contrasts between light and dark colors.*

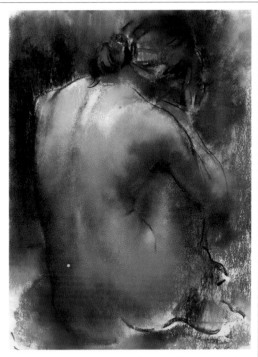

Nude in pastel painted by Francesc Crespo. The color is subordinate to the intense values of chiaroscuro.

fresh palette, filled with hues. This palette also allows light and shadow to be expressed, except in a more brilliant manner: the shadows are not dark gray (as they are in academic paintings) but are

Flat Colors

Untoned colors are completely "flat." They do not create the sensation of relief and volume as shadows and different intensities of tones produced through mixes do. By painting with flat colors, the artist highlights the form through contrast, bringing out the contours but without relief or a third dimension.

blue, violet, carmine, and so on—dark colors in themselves but with a chromatic tendency infinitely superior to that of dark browns. Light and shadow become, in this manner, pure color. The shadows possess as much colorist interest as the highlights and the entire surface of the work appears to vibrate. This vibration is essential for the pictorial treatment of the nude, a subject like none other that favors transparency, lightness, and freshness of color.

Intensity of Light and Color

The nature of color is such that light is always suggested. Tones of yellow, pink, blue, pale green, and in general all light colors give off varying degrees of illumination. The

same happens to the shadows: a violet shadow is a fresh and lively shadow, a carmine shadow is dense and evokes profound darkness. If we consider the infinity of shades that colors offer and their correspondence with as many other highlights and shadows, one reaches the conclusion that the possibilities are limitless.

MORE ON THIS SUBJECT

· From the Drawing to the Painted Nude, **p. 62**
· The Nude with Values and the Colorist Nude, **p. 66**
· The Color Ranges, **p. 68**

THE NUDE WITH VALUES AND THE COLORIST NUDE

Value painting and colorism are the two most important painting procedures. When the nude is painted with values, the artist concentrates on anatomical description and the effects of light on the figure. The aim in a colorist work is to apply flat colors and obtain pure contrast through tones.

Painting with Values

The chapter relating to shading explained that values are varying intensities, lighter or darker, of a single color. In a value painting, the artist reduces the range of colors to a very limited number, which is increased by lightening and darkening said colors. The value painter begins with one color (the so-called "local color") that is darkened or lightened with values of the same color (darker or lighter tones) or similar colors. The value painting tends to place emphasis on the forcefulness of volume, the intensity of the modeling; nudes painted in

The volume and color in this work by Joan Raset are balanced. Each cedes part of its potentiality in order for the other to manifest itself. The modeling is modest and the color does not reach its maximum intensity. Colorism and value painting share a common chromatism.

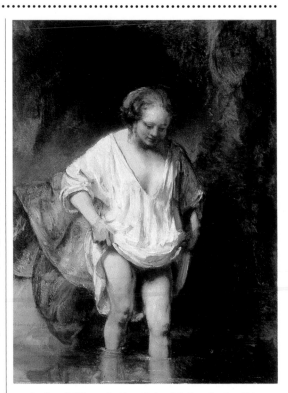

Rembrandt, Woman Bathing. *National Gallery, London. Value painting is based on the alternation of highlights and shadows, by gradations of color and not by pure tones.*

this manner have a powerful chiaroscuro that makes them stand out against the background and acquire a sculptural relief. Value painting was the traditional method of all the great masters of the nude genre from the Renaissance to Impressionism, and it may be one of the reasons that it is considered a more realistic, or more normal, representation of the nude.

Painting with Colors

The colorist tendency was introduced definitively into European painting by the Impressionist movement. The Impressionists were absorbed in color in all its plentitude and avoided the exaggerated chiaroscuro of academic painting. They wanted to express the splendor of nature only with color. In general terms, colorism consisted of turning the

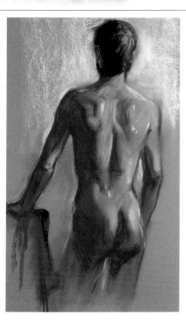

This pastel painting by Vicenç Ballestar has a decidedly value style: the color is limited to the minimum in favor of the interplay of the values of light and shadow.

Color and Chiaroscuro

The nude can be executed in one way or another and the results may be equally interesting in both. A nude painted in chiaroscuro gives the figure a sculptural appearance. Painting in the colorist manner, on the other hand, depends on flat color, areas of color contrasts, a total or partial absence of volume, or a corporal nature.

nude's highlights and shadows into different colors instead of different values of the same color. Black as a tone for darkening is avoided, favoring blues, greens, violets, and others, in order to exalt, at the same time, the yellows, oranges, and very light grays. The colorist painter expresses the shades of color of the figure's highlights and shadows according to the degree of coolness or warmth the greens and blues may possess. They may even exaggerate these colors in the same manner as Expressionists and search for a maximum chromatic intensity.

The Intensity of Color

The artist must choose between the values of volume and the relief and the values of the color according to their personal inclination or preference. The decision, nonetheless, is not as drastic as it might seem at first: painters can work with both techniques depending on the subject matter and their mood at the time, choosing between the two freely, so long as they know what they are doing, with the knowledge that either one of them will lead to highly distinct results and, occasionally, almost diametrical.

Values and color, shadows and chromatism, exist together in reality. The painter must decide whether to paint the work in the value or the colorist manner.

THE COLOR RANGES

Regardless of the medium used, the painter must understand the technique of color harmony. This procedure is based on ranges of harmonic tones. Each one of these ranges has specific characteristics. The nude requires the use of determined color ranges as well as the intervention of contrasting tone from other ranges.

The Idea of Color Range

We know by intuition that certain colors go together better than others, something akin to "family gatherings" of tones that are compatible. There are three main ranges or families of color: the warm color range, the cool color range, and the neutral (some-times called "broken") color range. The classification of these ranges is psychological, and as such is difficult to prove scientifically, although it is quite obvious when one contemplates the matter.

This work by Joan Raset has been painted with warm colors. This is a logical choice for a nude because flesh colors are warm.

In this composition of warm colors, we can see a basic number of yellows, oranges, and reds together with many tones that extend from ochre and sienna to warm greens, to pinks and carmines.

The Warm Range

The warm range of colors includes all those colors ranging between yellow, orange, and red. They are colors related to light, blood, human flesh, sand, and so on. None-theless, a warm green color may appear cool when surrounded by warmer colors, but when situated among cool colors will "increase its temperature." Therefore, it is also important to include a certain number of cool tones among a number of warm ones, because the cool ones will make the warm tones stand out.

The Cool Range

Cool colors are those related to the colors of blue, bluish green, dark violet, mauve, and gray of a green or blue tendency. When compared with the warm colors, these appear to distance themselves from the spectator, and their psychological effect produces a feeling of tranquility, stillness, or freshness. Just as in the case of warm colors, cool tones depend on the colors that surround them. Therefore, the warmer the adjacent colors of the composition, the cooler a blue will appear.

The Neutral Range

Neutral colors are "impure" colors, those that tend toward a color but never actually get there. Neutral colors include greenish siennas, reddish

Except for the pink and orange tones of the figure, all the other colors of this composition by Joan Raset can be considered part of the cool range of colors.

The range of cool colors includes blues, bluish grays, violets, mauves, and cool greens. These colors can be extended to take in the most subtle of tonal combinations.

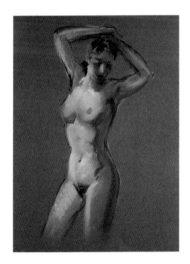

Notice the somber effect of the neutral range applied to this nude painted in pastel by Vicenç Ballestar.

The range of neutral colors includes many different colors all classified into a single range, often called "broken," that is a complete lack of tonal saturation.

browns, shades of white, browns, and so on.

Their name indicates that these tones are not as pure as primary or secondary colors.

Neutral colors may tend toward the warm color range or the cool color range.

The Color Ranges of the Nude

The predominant color in a nude work is, without doubt, the color of flesh. But flesh color, as is described in the next chapter, can take on numerous tendencies (ochre or warm to a greater or lesser degree), and, as a rule, does not present any defined color saturation. The shadows of the nude abound with neutral tones, pale greens, bluish grays, and also sienna and pinkish tendencies. Furthermore, it is impossible to determine a single range for the nude without also considering the tones that surround the figure. All these considerations make the execution of a nude one of the most interesting painting activities in terms of handling color.

FLESH COLORS

The color of human flesh is the painter's greatest chromatic dilemma. A color changes according to the lighting conditions and therefore must never be employed in the same way in every painting. Certain colors are common to all manner of flesh colors, while others tend to occur only in areas of the skin in shadow.

The Color of Flesh

Inexperienced painters tend to think that there exists such a thing as a "flesh color" paint that is used to paint all human figures. However, there is no flesh color, just as there is no "sea blue," unless we are

This table shows a few of the many ways an artist can obtain a flesh color by means of a mixture of blue and sienna plus white (top mixture); ochre, red, and sienna plus white (central mixture); and green and red plus white (bottom mixture).

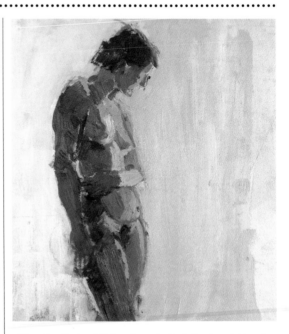

The colors Muntsa Calbó used to paint the flesh colors of this nude were all obtained from mixtures based on yellow, red, blue, sienna, and white.

referring to industrial painting, billboards, or similar productions. Neither the color of the sea nor the color of flesh possesses a concrete color. Of course the color of the sea always oscillates between blue, greenish, and gray tones; likewise the color of caucasian human flesh tends toward tones of pink, light ochre, sienna; in other words, colors of a warmish tendency. But paint manufacturers don't sell tubes of flesh-colored paint,

because there are many shades of human skin, from very dark to very light, and it is the job of the artist to create the most suitable color of flesh for the work in question.

The Qualities of Skin

All artists interpret the color of flesh in their own way. Some painters begin with an orange ochre tone—a very intense skin tone—as a base color that can be darkened with burnt sienna or red or lightened with a cool white. Others prefer to start with a basic pinkish, almost white, tone for use as a

flesh color, which can be darkened with pale green or blue (light shadows) and red and carmine (dark shadows). Impressionist flesh colors, of the type used by Renoir and Cézanne, contain a wealth of tones and different colors, from violet to vermilion to gray and orange. An examination of the flesh colors of nudes painted by the great masters instantly proves there is no universal flesh color. Pictorial flesh colors are free interpretations of the qualities of the skin under the action of light.

Highlights and Shadows

The flesh colors of the nude must always help to express the highlights and shadows cast over the model. The shadows may be dense and profound, or light and transparent. The highlights may be intense or filtered, direct or indirect. Furthermore, flesh colors vary according to colors surrounding the model. When working with a cool gray background, a warmer tone (such as a light sienna) is enough to make it stand out with an almost burnt intensity against the background. This intensity may then be toned up or down by surrounding the figure with other colors that bring out flesh color (e.g., applying an intense red around the model will turn the flesh color pale). Therefore the color of the human skin is a product of the color scheme of the work and is thus modified as the work progresses, fading, rectifying, or intensifying the color in question.

Range of Flesh Colors

An appropriate range of flesh colors should contain tones of ochre, sienna, and earth as a foundation for modeling the figure in chiaroscuro. The touches of pure and vibrant color such as vermilion, yellow, blue, and intense pink are added in order to bring out the highlights, reflections, and darkest shadows. This is merely a suggestion or a starting point from where different possibilities can be tested, without forgetting that the darkest tones must be used with great precaution in order to avoid effects that appear too strident. Another procedure is to play with the colors surrounding the figure so that, by the effect of contrasts, the flesh colors are highlighted. A figure surrounded by grays and blues will always appear warmer than one contrasted with red and yellow. Whatever the case, it is essential to take into consideration the internal and external colors.

The flesh colors in this painting by Muntsa Calbó are much cooler than those of the work on the facing page, due to the use of black in the mixtures.

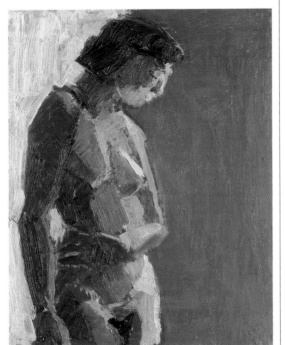

These are the mixtures used to paint the adjacent nude.

MORE ON THIS SUBJECT

• Value and Color, **p. 64**
• The Nude with Values and the Colorist Nude, **p. 66**
• The Color Ranges, **p. 68**

TECHNIQUE AND PRACTICE

COLOR CONTRASTS

To work with color is to use contrasts. It is thanks to contrasts that the nude acquires its profiles, volume, and situation within the space of the representation. These contrasts may possess a strictly realist intention or emphasize the form and relief of the nude's anatomy.

Simultaneous Contrast

The effect known as *simultaneous contrast* (which some writers refer to as the "law of simultaneous contrast") is based on lightening or darkening of a color as a consequence of its contrast with the adjacent color. When gray is surrounded by blue, it appears almost white; on the other hand, when carmine is surrounded with white it will appear darker than if we surround it with black. The greater the number of different tones used in a work, the greater the contrasts created. This can be tested by applying pale washes of color ranges over the color of the support: the tone of the support will make the colors stand out to a greater or lesser extent. This effect allows the painter to intensify or dampen colors by means of the ad-

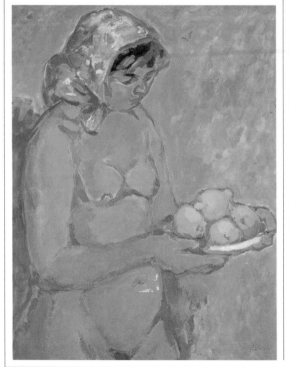

Teresa Llácer, Offering. *Private collection. A surprising green flesh color that, nonetheless, appears coherent in the work's general color scheme. It represents a fine example of the autonomy of color with respect to the reality of the model.*

Mercedes Gaspar, Nude. Private collection. The flesh color qualities of this figure are further intensified by the contrast with the blue.

jacent colors, creating simultaneous contrasts.

Accentuating the Contours

Thanks to simultaneous contrast, the painter can highlight or bring out the nude's contours without having to enclose them in a dark line, which so often supports and produces a rigid form. The procedures consist of lightening the colors of the background in the areas of the figure's darkest zones and darkening these colors to the maximum. By painting around a light shoulder with a darker color, it is possible to create the outline without the need to draw one in; the same happens when surrounding a dark figure's exterior with a light color. In this way, the drawing

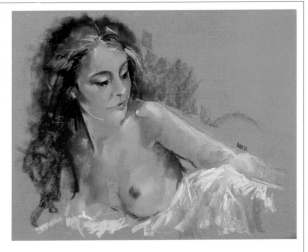

The contrast produced between the color applied and the color of the paper (ochre) has allowed Salvador G. Olmedo to paint this figure with few resources. The warm and soft tones blend perfectly within the ochre color of the whole.

and the color merge to form an inseparable whole: the lines originate from the colors. This technique is especially useful in achieving chromatic continuity and preventing the colors from being interrupted by unnecessary lines and strokes. Another possibility of simultaneous contrast consists of highlighting the intensity of color by applying adjacently a toned-down version of its complementary color. For example, orange can be intensified by applying a light grayish blue next to it; red can be intensified by placing a dull green adjacent to it, or blue can be made to vibrate when placed next to toned-down yellow.

Transitions

The utilization of simultaneous contrasts as a technique for defining the outlines without actually using lines is only successful when it is not carried out systematically. If a figure is enclosed on all sides, it will look artificial and confined. Allow the color of the figure and the background color to merge at certain points. This way the background will be recognized as the space within which the figure is situated and not as an independent plane in which the figure stands out from a seemingly detached background. This is fundamental, given that a lack of interest in the relationship between the figure and the space it occupies has led to numerous unsuccessful creations.

The flesh colors of this work by Joan Raset have been dealt with very simply, using only one or two colors. The work does not look flat thanks to the subtle intensities of tone that evoke shadows and the modeling. The choice of a sheet of pale ochre paper also contributes to the naturalness of the effect.

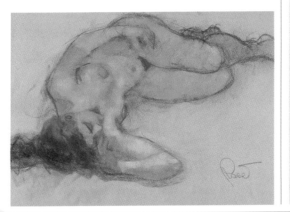

Contrast of Ranges

By taking color ranges into account, it is far easier to foresee the result of a chromatic contrast. Warm colors contrast with cool ones, thus creating a sensation of depth. By adding tones of neutral colors to this contrast, the possibilities of the contraposition of tones to highlight the colors of the figure increase significantly.

TECHNIQUE AND PRACTICE

SPACE THROUGH COLOR

Color can be used to create space in a work independently from the drawing or the perspective. The contraposition of color creates a sensation of space. The contraposition of warm and cool colors, among saturated colors, produces an effect that goes beyond the mere coloration of the nude and affects the definition of the space of the canvas.

Warm Colors and Cool Colors

Color contrasts create a sensation of space. To be more precise: the contrast between two colors suggests a distance between them, one always appearing closer than the other. This impression of distance is even greater when a warm color is contrasted with a cool one: warm colors appear to come closer while cool colors distance themselves. All painters are aware of this fact and use it in their works. A form in the foreground can be painted with an intense warm color (such as yellow or orange) and can be contrasted with cool colors around it. These cool colors appear to recede towards the background. This is a means of creating space without the use of perspective, which in the nude genre does not play much of a role. The color distance factor allows the artist to paint a picture using colors that are cooler than those of the figure for the background and, especially, cooler than the foremost planes of the composition.

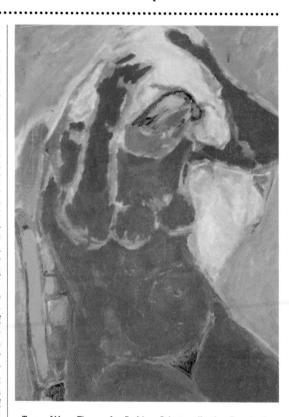

Teresa Llácer, Figure after Bathing. Private collection. Despite the fact that the contrasts between the figure and the background could not be greater, we can observe transitional zones, such as the towel in the top left-hand side.

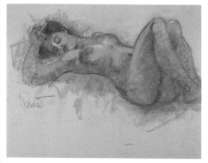

In this painting by Joan Raset, the figure and the background are the same color and are only distinguishable from each other by the superimposed contour.

Space Through Contrast

Another way of conveying space in a composition is by contrasting values or intensities. This type of contrast must be vivid in order to yield results, otherwise it will be lost among the basic tones and colors. For example, a very dark form placed on a light background appears to advance, in the same way that a

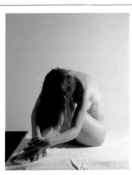

A figure placed under illumination as contrasting as this always displays points in which the shadows merge and some forms acquire the same tone as others. We can see this effect here in the hair with respect to the arm and the legs.

space by means of shadows and tonal gradations, the colorists must express depth in their works through impacts between colors. As a rule, this is executed by contrasting soft tones with intense ones, searching out combinations of complementary colors (which always intensify one another mutually) distributed between the figure and the background.

Space Through Fading

The third technique applied for spatial creation is contrasting through graying, or fading, which is linked to the famous "Ariel perspective" conceived by Leonardo da Vinci. The great master drew attention to the importance of softening the tones of objects as they recede into the dis-

tance. He called this technique fading, but it can also be called color attenuation. The forms of faintest color drift toward the background; if in addition to being faint the color is cool, the effect of its distancing will be increased further. Leonardo went on to say that the contours are also affected by distance. By combining the effects in a suitable manner, the possibilities of creating pictorial space are enormous.

very light form against a dark background also appears closer. This is because nearby forms contain greater contrast; they are more somber and at the same time lighter.

As can be observed, this is a consequence of simultaneous contrast, which can be combined with contrasts between warm colors and cool colors in order to achieve pictorial space. The color contrast is a technique used by all colorist artists to recreate space in their works. By not using the chiaroscuro, which creates

Nude and Perspective

Paintings based on the nude give the artist few opportunities to employ conventional perspective (the linear type used in the urban landscape genre). Color is responsible for the description and value of the space. In addition to space-creating color contrasts, there is the question of foreshortening, which on its own would produce a three-dimensional scene.

Teresa Llácer, Women with Oranges. *Private collection. The color contrasts are heightened with a prominent outline.*

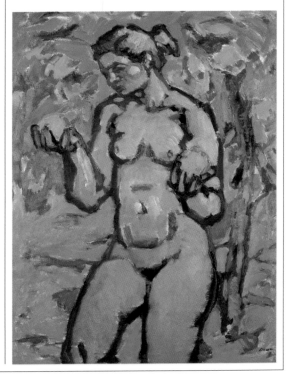

THE NUDE IN PASTEL

Pastel is the pictorial technique closest to drawing and the most common way to paint a nude. The characteristics of the pastel painting make it an ideal medium for formal and chromatic experimentation and for trying out new possibilities. In addition, the solutions obtained can be applied to oil painting quite naturally.

The Line

In general, pastel paintings are executed by means of the application of strokes—blended or unblended—of color. These strokes may be continuous or discontinuous, they may be simple (exclusively limited to outlines) or more elaborate. Whatever the case, the most important thing is that the nude's shape must be well constructed. A nude constructed with a long and continuous contour line requires close observation. The execution must be fast because free strokes do not allow hesitation. There is also the possibility of the stroke losing its continuity among other superimposed strokes. In such a case, each one of the lines must be of interest and the whole should give the figure a feeling of movement, as if the gesture of the arms, for ex-

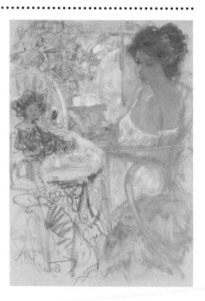

Work by Joan Raset. The stroke and the color applications or areas of color are the two fundamental structures that pastel painters can base their work on.

ample, had left a mark on the paper. As well as being visually attractive, this type of stroke possesses a high degree

of pictorial interest because it allows the artist to elaborate the form, highlighting it with shaded or blended areas, something that cannot be achieved with a drawing whose outlines completely encase the figure in a single contour.

The Shaded Area

Charcoal sticks allow the artist to execute both lines and shaded areas according to whether the stick is applied with its tip or with the full length over the paper. Shaded areas are also used to convey the areas or values of shadows that lend the figure volume. The smaller and more abundant the shaded areas, the more precise the modeling and the less lines are needed to explain form. If the painter

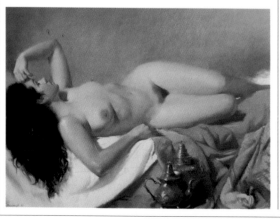

Santamans, Nude. Private collection. *Whether it be an Impressionist painting or a highly elaborated academic work, everything is possible in nude pastel painting.*

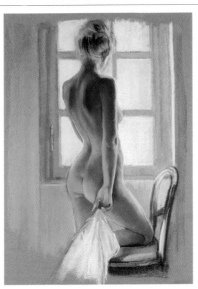

Pastel can be mixed well, but it is always better to use many small sticks of different tones instead of multiple blendings. Note the chromatic wealth of this work by Salvador G. Olmedo.

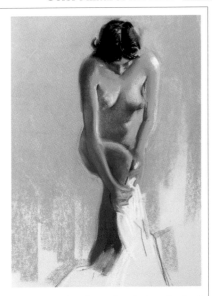

Pastel can be used to obtain such refined chromatic effects as those obtained with watercolor. This figure by Vicenç Ballestar was painted in pastel.

combines lines and shaded areas, he should avoid using both to describe the same thing. For example, if a stroke or a number of strokes are used to describe the shape of an arm with energy and visual grace, it is best not to add either shaded areas, shadows, or anything else, because this will not contribute to explaining what has already been "said" through lines. Indeed, such additions may even ruin the effects obtained. The same is true of a purely shaded drawing; if it is profiled with a continuous line, the result will appear to be a solid and slightly heavy mass, without lightness, and will thus be redundant.

Combining Lines and Shaded Areas

Although both the line and the shaded area can be used to describe form independently, they can be combined within the same painting with complete liberty, provided the artist does not attempt to express the same element with both. The general nature of the figure's volumes can be represented with several shaded areas, without being too precise; in the zones where shaded areas cannot be applied, the artist must use lines to finish off the shape of the figure, but without superimposing one type over another systematically. It is essential to remember that the intensity of the line can also suggest shadow and the juxtaposing of two shaded areas can suggest a line. In any event, it all boils down to practice in order to find solutions to the problems that arise in pastel painting. The best advice is when the form has been defined, it should not be insisted on too much.

Ranges and Color of Paper

Pastel is normally applied on colored paper. If the artist wishes to work with a warm range of colors (which is common in the nude genre), she can choose paper with a warm tone, while ensuring that the tone will not be confused with the predominant colors. The result produces a wealth of harmony that can even be livened up, if a sheet of cool grayish paper is used (such as green). The same goes for the cool range: a warm support (cream, light sienna) brightens the contrasts and lends the whole vitality. Almost any color of paper is suitable in order to paint with a neutral range of colors, except for those color tones that are too pure and saturated (such as vermilion or ultramarine blue), which cancel out the subtle quality of the neutral tone.

COLOR MIXTURES IN PASTEL

The pastel medium requires a special type of treatment that is unlike any other pictorial medium. Pastel does not need any implements other than the artist's hand and the stick of pastel. But the possibilities of mixing and combining colors are far greater than what these basic fundamentals may have you believe.

Stumping and Blending

Stumping or blending a color when painting in pastel is as easy as rubbing a finger over a color application previously applied with a stick. New strokes can be applied over an area, which can then be blended with the underlying application in order to obtain a certain result. This technique, as well as gradations from one color to another, can be carried out at any stage of the painting process. Even though stumping and blending can be executed with other implements besides the hand (e.g., a stumping pencil or a rag), they are not as useful and suitable as the fingers or the palm of one's hand. The artist can control the pigment more easily with the hand and have direct contact with the work. The only precaution required is to clean your hands from time to time so as not to dirty the surface of the work. This technique allows the artist to enjoy greater comfort and freedom of movement; the work is more spontaneous because the artist has direct contact with the support and does not have to pause to look for a suitable instrument. Pastel artists use their fingers as much as their pastel sticks, and on rare occasions a stumping pencil.

The Abuse of Stumping

Excessive stumping of pastel fills in the pores of the paper, making it difficult to apply new colors on top. It is important to remember that pastel is a medium that demands freshness; therefore, too many colors can end up ruining the work. One way to avoid this situation is to begin the work with hard pastels and then continue on with soft ones. This method allows the artist to first apply the darker tones and then continue with the light ones. Furthermore, if you are not satisfied with a color, it is preferable to make the mistake of applying a highlight excessively, given that this type of error can be toned up or down more easily than turning a neutral color into a pure one. This way the artist avoids the unpleasant whitish aspect, akin to plaster, that pastels acquire when they have been worked on too much.

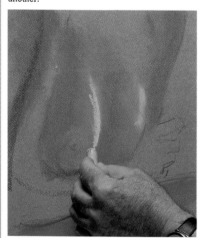

In the execution of this work by Vicenç Ballestar, the pastel colors have been applied pure, without mixtures, superimposing one over another.

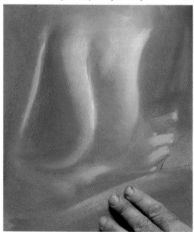

In pastel painting, stumping often means blending colors: the previously applied tones give way to a perfectly mixed tone.

Superimposing

More than stumping or blending, painting requires more superimposing of tones. Thanks to the grain of the paper, the color (applied with the flat part of the stick over the paper) does not entirely fill in the pores and allows the underlying layers of colors to "breathe" through the texture left by the superimposed color. In other words, the base tone will be visible in the areas of the paper whose pores have not been filled in by the superimposed color. Although stumping is not to be completely shunned, it is best to use individual colors when the color is applied pure on the paper and does not superimpose another. Too much

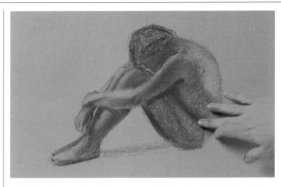

During the pastel painting process, the tonal unity is obtained by means of stumping with the fingers.

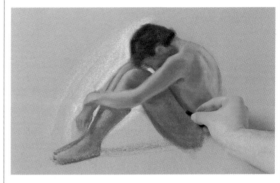

Over the general color scheme, the artist adds details and highlights that lend relief to the form.

Juxtapositions

The same precautions as those referred to in stumping should be taken when blending colors. Otherwise, in the worst case scenario, they will dirty the work. Blending can be substituted by (although not always) juxtaposing colors, similar to what the Impressionists did when they applied individual strokes, in the form of touches of color that do not blend together. To juxtapose is to apply one area of color next to a different color, without allowing their limits to merge. The visual effect of juxtaposing produces a work of pure planes of color; the broader they are, the more intense the effects of contrast between light and shadow.

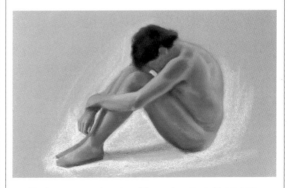

The last stage consists of touching up in order to highlight the contours of the figure and make its color stand out.

stumping makes the pastel colors look unnatural; they lose their intensity, and this effect is worsened as more colors are stumped. The end result is a dull color scheme, and the contrasts lack their original impact.

THE NUDE IN WATERCOLOR

Watercolor is a medium that requires agility. It is a direct medium that compels the artist to apply the stroke, and the nude in general, with resolution. In other words, the painting must be a synthesis and there is little margin for error. The results obtained lend the work a luminosity that is impossible to achieve with any other medium.

Mastering Water

The watercolor medium is based on the control of water. This is an indisputable fact that determines all aspects of the procedure. Be it the mixing of colors or the mastery of the drawing, watercolor requires the painter to develop a sense, a special intuition concerning the behavior of liquid color, diluting it to a greater or lesser degree, adding more water to the previously applied area, drying it with a completely dry brush, wetting the paper before color is applied, or adding strokes over a dry support.

Process of the Nude in Watercolor

The procedure for painting a nude in watercolor begins with the preliminary drawing. This can be executed in pencil or charcoal. If the drawing is done in pencil, the lines must be drawn faintly, without allowing the lead to leave too much of an impression on the paper (watercolor paper is soft), because the furrows become visible when color penetrates them. If you work with charcoal, it is essential to go over the lines with a cloth once you have finished in order to remove the charcoal dust that can dirty the paint to be applied on top. Watercolor is a highly luminous medium (the color is transparent and the underlying white of the paper illuminates the colors) and allows the maximum contrast between light and shadow to be accentuated. Therefore, the artist must know

In watercolor painting, the artist must gradually increase the intensity of the color by starting with light tones and working towards darker ones. The flesh color here is a transparent ochre.

Once the values have been established, the dark colors of the figure are intensified.

The last stage is for adding details and small shadows.

exactly where the light areas and dark areas should be situated. The light areas will be the white of the paper, and

for this reason they must be reserved from the outset. The rule is to start a nude painting with a subtle wash (a color that

has been very diluted in water) to obtain the general tone of the flesh color. This tone can then be shaded with new colors, while it is still wet, to obtain the direct mixtures; or a new tone can also be applied onto a dry area of paint, the result of which produces tones in which the brushstrokes are perfectly visible.

A Light Medium

Watercolor is a light and luminous medium that offers results that are unequaled in nude art. Expressed through the medium of watercolor, the surface of the human body appears soft and silky, containing continuous and harmonious colorations. The free and spon-

taneous applications of color are not only a possibility but constitute one of the most important attractions of this medium. Areas of color, freely applied with the brush, simultaneously provide a synthesis of form and color that can be used to paint the entire nude, working from the first synthesis. Furthermore, the spontaneity that characterizes watercolor makes it an ideal medium for painting sketches.

Spontaneity

By studying reproductions of sketches and notes executed in watercolor by famous artists, you will see how the great masters were able to capture in a few brushstrokes

Wash or watercolor with one color, like this example by Vicenç Ballestar, is one of the most commonly used media for sketching notes.

such complex questions as illumination, composition, color harmony, and so on. The sketch provides the artist with the most essential information on the subject, without its being exhaustive or in depth. A good watercolor reveals the artist's talent of spontaneity and creative freedom.

A version of a painting by Rounalt, here executed by Vicenç Ballestar: the free brushwork is one of the factors that lend vitality to a nude in watercolor.

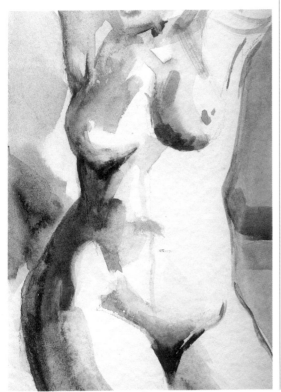

Watercolor and Gouache

Some watercolorists use white gouache (an opaque color) to represent the subject's highlights. Although many traditional painters scorn this technique, it can be used to create interesting results. In any event, gouache can be used on its own, allowing an oil paint-like result, or it can be used in conjunction with other media to highlight specific parts (e.g., with lead pencil, chalk, or pastel).

TECHNIQUE AND PRACTICE

THE NUDE IN OIL

Oil is the most prestigious of all painting media. Most of the nudes painted throughout the history of art were executed in oil. This implies that all the factors involved in nude painting, whether the subject is male or female, can be studied using this medium as a reference source.

The Nude in Oil

Most of the nudes painted throughout history were executed in oil. This simple quantitative factor makes oil the unrivaled painting medium. On a qualitative level, one must consider the enormous breadth of variety and chromatic quality that this medium allows, its possibilities in terms of textures, color corporeity, the possibility of painting a work indefinitely, bringing out its detail, and the ease with which the form and color can be altered or rectified. Oil is, without a doubt, an excellent medium for painting any type of subject matter, including the nude. One of the most sig-nificant advantages of painting a nude with oil is the large number of colors available for the painter to obtain the right flesh colors for the model, from hues of yellow and green, to pink, to the siennas, to the cool green and blue tones for shadows. The oil medium comprises a wealth of color with which the artist can explore the nude genre.

Process for Painting a Nude in Oil

The oil painting begins with a preliminary sketch of the nude in pencil or charcoal. The general outline need not be elaborate, but instead should be flexible enough to allow the decisions and emotions of the moment to be reflected in it. Once the nude has been sketched, the entire canvas must be roughed out with the approximate color, without fear of making mistakes. The next step consists of constructing the picture, drawing with color, specifying the most important forms and creating the effect of light and shadow, vivacity and contrast. Now the color is the main feature and must be rich and abundant. Later in the final stage, the artist can adjust the different observations that he gradually gleans from the nude.

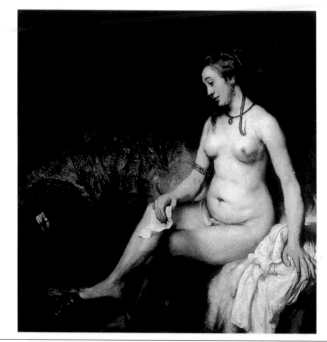

Rembrandt, Bestabé in the Bath. *The Louvre, Paris. Most of the great masterpieces were painted in oil.*

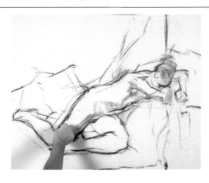

Charcoal is the most commonly used medium for the preliminary drawing of an oil painting. At this stage, the artist must draw in all the most important aspects of the drawing and composition.

Roughing out the canvas can be carried out with thick paint.

The first stages must be executed quickly, roughing out the canvas with broad strokes. The development of the painting is the toning up or down of the previously applied color.

The final result of this painting by Miquel Ferrón can be observed in the great versatility of oil to paint the highlights, shadows and flesh colors of the nude.

The Importance of the Stroke

In the oil medium the stroke is not used only as a means to build up the color but also as a genuine compositive resource. Oil allows the line to be hidden under the applications of paint, leaving a soft, smooth surface. Nonetheless, modern nude painters who work with oil prefer a treatment that gives the brushwork relief. Since the oil is applied thickly, the strokes contain a more heightened intensity and presence than those of all other media. The artist must take advantage of this to define the subject with the brushstrokes, using them not only to create the contour of the nude but also its entire shape. This is how most of the Impressionists worked (and many modern painters still do) and this is the reason that their paintings look so fresh and spontaneous.

MORE ON THIS SUBJECT

• The Nude with Values and the Colorist Nude **p. 66**
• Flesh Colors **p. 70**

The Problem of the Grays

Regardless of the medium, there are always certain mixtures that produce gray. Oil, which offers so many facilities to blend colors, is the medium that most succumbs to this excess of gray. When painting nudes, the artist must avoid getting bogged down with grayish colors due to excess blending. When a mixture begins to acquire a grayish tendency, adding white will not solve the problem, it will only make matters worse. Grays are perfectly valid (and necessary) when they are used correctly, but when they are the result of an accident, they reveal the painter's lack of knowledge of the laws of color blending. To sum up: beware of indiscriminate color blends in your work.

INTERPRETING THE NUDE (1)

The nude subject contains an enormous psychological element. So, it is essential to regard those aspects that transcend the purely technical nature and to concentrate on questions of meaning and expression and the aesthetic attitude that presides over a work of art.

Interpretation

Interpretation is defined as the personal way in which each painter decides to approach the subject. To use a musical metaphor, we might say that the female nude is the artist's sheet music and the finished work is the interpretation. All interpretation is essentially personal, regardless of how realistic or apparently objective it may be.

In addition, interpretation is indispensable if the artist is to lend interest to the work and stir the spectator's curiosity toward it.

To interpret means to emphasize those aspects of the model that most catch the painter's attention: the color, the line, the harmony of the pose, the movement, the lighting, and so on.

Ramon Sanvisens, Figure Removing Her Blouse. *Private collection. A modern interpretation of the nude in an energetic and colorist manner.*

William Blake, The Genius of Shakespeare. *British Museum, London.*

Realistic Interpretation

Realistic interpretation is always relative, as realism in painting is a highly variable aspect. But it should be stated that the realistic interpretation of the nude is just one of many possibilities. It is an interpretation sought by many painters: the search for the truth of the human body, without stylization or embellishments. This approach is prevalent in masterpieces and in many works painted by contemporary artists.

This type of interpretation is often solemn and tends to individualize the figure to a great extent, giving it personality, character, and psychological or moral aspects; for this reason such interpretations suit the portrait genre (with a dressed or naked figure) more than the sensual treatment of the nude.

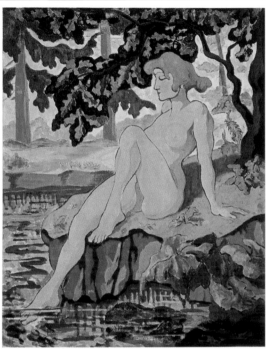

Paul Ramson, Bather. *Gelería de Lavante, Rome. An imaginative interpretation influenced by Romanticism and twentieth-century Avant-garde tendencies.*

Romantic Interpretation

Unlike the realistic interpretation, what we often call the romantic interpretation, is the type in which the artist seeks out the most sensual, emotive, or refined aspects of the nude, and expresses them through poses, gestures, a brusque movement, or the complements that are included alongside the figure. It is, therefore, an interpretation that attempts to avoid too much intense psychological profundity, and that prefers to reflect aspects like impetus, agility, charm, elegance, and the eroticism implicit in varying types of male and female nudes. This interpretation stresses the importance of the fleeting moment of the pictorial climate.

Abstract Interpretation

The abstract interpretation of the nude underscores formal aspects, the continuity of the volumes, and the pure harmony of the color and linear composition. It is the least psychological of all the interpretations described. The artist does not express the model's character or the moment in which it was painted; rather he creates an architecture of shapes and colors based on the formal information of the view. This interpretation also leads to astounding artistic results.

Intimism

One pictorial genre in which artists paint figures is *Intimism*. As its name suggests, it is a style concerned with domestic interior scenes of an intimate nature. Although there are many examples of this painting in a variety of styles and periods, the most common are nineteenth-century scenes of the interiors painted by the Impressionist and post-Impressionists.

Work by Joan Raset. The artist's style is representative of modern interpretive nude tendencies, very much influenced by Impressionism and abstract painting.

INTERPRETING THE NUDE (2)

To interpret, in the strictly pictorial sense, is to select, increase, or suppress the more or less significant parts that intervene in the work to be painted. It is to bring out the essence and give less importance to accessories. The criteria that govern this activity must be based on the primacy of the work's expressiveness.

Visual Choice

When artists observe and study the model's body, they are choosing the pictorial aspects, separating them from everything that lacks artistic possibilities. Experience in painting allows us to choose, for example, specific chromatic qualities, those that provide the best possibilities for the interplay of tones, superimposing, and the freshness of the stroke. Experience also allows us to leave out details that are difficult to express as secondary elements. The attitude of copying everything does not have much sense and ends up creating overloaded and rather unexpressive pictures. Keen visual selection is essential if the artist is to paint a fluid and comfortable work, without constant rectifications and additions that can lead to a confusing picture. Skilled painters see only what they want and need to see.

Copy and Creation

The difference between the copying of a figure and personal creation depends on what was mentioned in the previous section. The figure is not an object to be copied but a subject that must be recreated by means of pictorial developments.

From this point of view, there is little sense in striving to attain a strict appearance of forms and colors and becoming a slave to them. The aim is not the reproduction but the creation of an attractive work in itself. If the real nude is attractive in itself and is situated in conditions of pleasant lighting, color, and surroundings, better still. Take advantage of all this wealth in the work, but don't attempt to capture a replica of what you see before you. Instead concentrate on the harmonic

Choosing the most important aspects, everything that has chromatic and compositive values, and avoiding anything that lacks pictorial development possibilities, is one of the artist's main tasks. Observe in this painting by Joan Raset how the artist has removed unnecessary details.

Rubens, The Paris Trial. National Gallery, London. In the great Classical compositions, and despite their complexity, there also exists a visual selection and creation that transcend the reality of the artist's models.

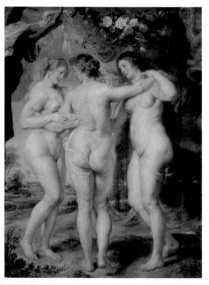

development of the aesthetic possibilities it offers.

Fantasy

Fantasy and invention are not the exclusive domain of abstract painting, of painters who invent forms and colors from start to finish without relying on an exterior visual reality of the painting itself. From the model, it is possible to invent and introduce at the same time the artist's own fantasies of form and color. The painter may lengthen or shorten an arm or a leg in order to accentuate the harmonic sense of the whole, or change a hairstyle by increasing or reducing the amount of hair, lightening it or darkening it. It is also perfectly acceptable to force the curve of the back or the shape of the neck when the situation calls for it.

It should be pointed out that all fantasy deriving from deformity must fulfill a pictorial purpose to increase the work's plastic interest. It must be viewed as value and not as clumsiness or arbitrariness.

Fantasy is freedom based on knowledge and experience and not on a pretext that hides lack of skill. The same goes for

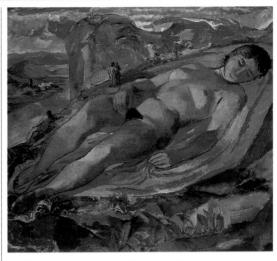

Albert Weisgerber, Woman Resting in a Mountain Landscape. *Neue Pinakothek, Munich. To invent a landscape from the model's pose is a perfectly valid creative possibility. The important point is to ensure the background is suitable, in terms of color and the nature of the pose.*

color: if a painter senses that a red may look more interesting than the gray or ochre he is observing, he should use red without fear. Creative painting is based on freedom and not on obligation.

The Visible and the Invisible

One of the attractions of painting nudes is the way in which artists suggest the forms without actually representing them in their entirety, leaving it up to the spectator to work out the form and complete it in his mind.

This should not be merely regarded as a possibility but as an important factor in avoiding the work of excess literal representation.

Framing and Trimming

The adaptability of the scene to the format is a balancing factor in the work. But balance must not be achieved at the expense of sacrificing the interest of the composition. The artist can obtain a balance by trimming the scene so it appears to have been captured at random.

Version by Vincenç Ballestar of a painting by Joaquín Sorolla. The emphasis lies in the interpretation of the light and the reflections on the water.

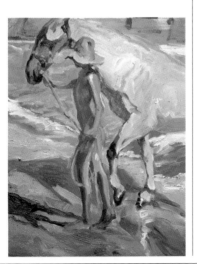

STYLIZATION

What is meant by stylization is the highlighting of a nude's harmony, that is, linear harmony and color harmony. There is always a stylization, but the artist can highlight the model, placing emphasis on the elegance of the pose, the forcefulness of the volume, or the brilliance of the color.

Form and Style

Characterizing and defining pictorial style is no easy feat, and, possibly there will never be an adequate definition. By intuition, we can ascertain that style is a series of technical resources and aesthetic values that characterize the artist's oeuvre. The painter's work is characterized by a series of aspects that show in all or most of his or her works: these aspects comprise the artist's style. One of them, perhaps the most important of all, is the comprehension and construction of forms. Some artists use full and rounded forms, some prefer more schematic representations, some stretch the forms of their figures out and others prefer to lend them a rough or soft touch. Even when painting the same model, no two painters will obtain an identical result; they see the model in their own particular

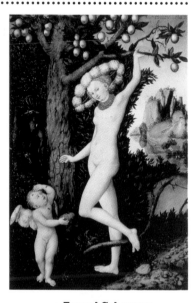

Lucas Cranach, Venus and Cupid. National Gallery, London. The stylizations of the female forms in this work maintain a coherence that extends to the rest of the forms in the painting: the arms and the branches, for example, have been given the same linear treatment.

way, using their own stylistic tendency. Stylization refers to the process by which the view of the model is represented on paper or canvas.

Formal Coherence

The stylization of form is partly unconscious and partly voluntary. The unconscious factor is the painter's spontaneous response to the nude. The conscious factor is that which derives from the artist's will to achieve coherence among all the forms and obtain a convincing unity. Stylization of the body does not imply deforming its arms and limbs, but rather their submission to the same formal "law." If the painter's style is angular, all the forms must possess the same degree of angularity, otherwise the body will appear incoherent and deformed. Nonetheless, it should be pointed out that formal coherence is the consequence of the style itself, and this style is a feat that the painter can only attain with time and work, not by applying rules.

Stylization can also be present in the pose. The artist can choose a sophisticated pose, such as this one by Joan Raset, in order to develop linear and compositive sophistication.

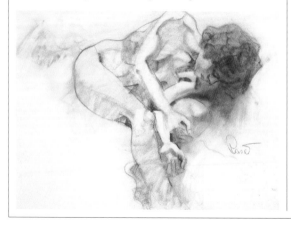

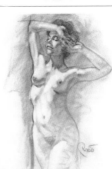

Expressiveness exists in the way the drawing or painting media are used to convey subject matter. It may originate in the treatment of the anatomy or the lighting. The pure chiaroscuro of this work by Joan Raset can also be a factor to heighten expressiveness.

Expressiveness

This is another difficult concept to define without ambiguities. Applied to the nude, we could say that a work can be considered expressive when it has life, internal vitality, when the figure appears to be animated and not as a cold and perfect representation. If the painter is able to capture the nude's existence, she has managed to be expressive.

Scene Painting Complements

There is nothing wrong in inventing a setting for a painting, a small fictitious world that will pave the way to the fiction that is the painting in itself. These fictions can be created through the choice of furniture if the artist wishes to situate the model in an interior. If the chosen setting is an exterior, then the color of the sky, the clouds, the plants, the highlights and shadows can be combined by the artist with total freedom, without incorporating any accessory.

Elegance

The elegance of the pictorial form is one of these concepts (such as that of charm) that are easy to appreciate in a work but extremely difficult to explain. Elegance is a characteristic of style that does not necessarily determine the quality of work; there are inelegant works of immense artistic value. In the nude genre, however, the elegance of the style is what the spectator immediately perceives and appreciates. Elegance is the product of the flow of the forms, the absence of superfluous details, the right choice of pose, the right colors. The artist must never repeat an absolute value, and the search for elegant effects in themselves can lead to superficiality and affectation. Elegance is intimately linked to naturalness and this is a value that is worth pursuing when painting the female nude.

Domingo Álvarez provides an elegant solution by the simplicity of the techniques employed. The synthesis and the search for the essence is a means to achieve a result of very interesting pictorial value. In this example the color is reduced to a series of soft and harmonic tones.

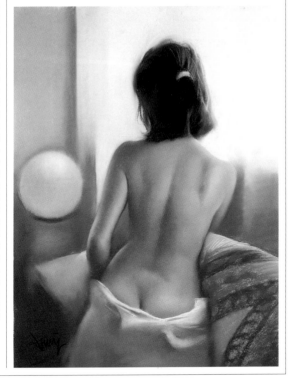

DRAPERY

Drapery is the traditional complement of the nude work. It does not perform merely an anecdotal purpose: it provides a formal counterpoint that helps to harmonize and highlight the nude's forms. In addition, it adds, if necessary, a touch of color to liven up the composition.

Drawing Drapery

Drawing drapery is another academic discipline, currently out of fashion, which traditionally formed part of drawing instruction. It consisted (and still does today, as it survives in some art teaching institutions) of capturing in pencil or charcoal the folds and creases and the general shape of drapery placed or hung over a chair or stool. The aim of this exercise was to give the student practice in drawing highlights and shadows, and in the construction of a complex and intricate volume. The origin of this exercise dates back to the time when artists represented tunics in all their detail worn by the subjects of Classical painting.

Abstract Drawing

Drawing drapery can be considered a genuine exercise in abstract drawing, given the geometric complication posed by the folds and their independence with respect to figurative forms. In this sense it is interesting to practice drawing fabrics and check how the problems of chiaroscuro and modeling arise in all their bareness. A brief examination of nude masterpieces, be they old or modern, is enough to see that the representation of fabric and cloth is almost a regular item: sheets, towels, curtains, and so on. There is always some type of creased fabric that falls or surrounds the figure. The reason for this should be left to historians and art critics. The

Drapery is a pictorial element that requires no figurative pretext in order to be shown in a work. Its role as a decoration to accompany the nude figure allows the painter to use it whenever he sees fit.

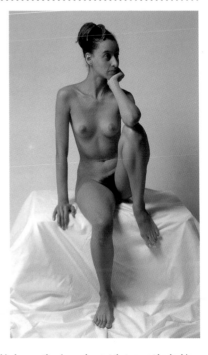

Drapery of one kind or another is an element that cannot be lacking in an academic drawing of this nature. Yet, fabrics provide the artist with the opportunity of free pictorial interpretation that is unconnected with the strict rules of traditional artistic teachings.

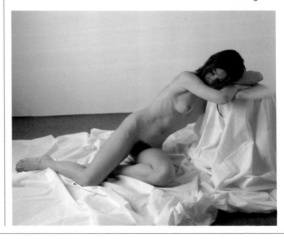

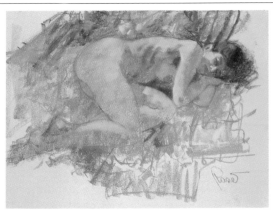

This work by Joan Raset is a fine example to illustrate the idea that the painter is not compelled to draw the folds in drapery in all their detail. On the contrary, they may provide a pretext for the artist to develop fantasy with complete freedom and free the work from excess seriousness.

thus creating great pictorial interest.

Simplification of Drapery

Having examined the subject of drapery in a certain amount of detail, it is evident that its interest is not merely academic. It provides today's artist with interesting opportunities. It is not necessary to obtain the precise folds and shadows as was demanded by tradition; instead, the painter can interpret drapery in an abbreviated and sketchy form, in consonance with the lightness that secondary elements should possess.

only thing that artists need to know is that drapery fits perfectly with the nude subjects, or complements them like no other element.

The Folds

The folds of drapery are, in effect, a splendid linear complement to the volumes of the nude figure. They also have a compositive interest, given that they allow, when the case arises, a pictorial space to be balanced by compensation of the excess weight of the forms by means of a series of more or less complicated folds. Furthermore, using a stamped piece of fabric as a model, the variety of folds and creases can heighten the intricacy of the drawing of the pattern,

MORE ON THIS SUBJECT

• Interpreting the Nude (1) **p. 84**
• Interpreting the Nude (2) **p. 86**
• Stylization **p. 88**

Drapery and Arabesque

Drapery can be given an arabesque treatment, and perhaps this is the best way to approach this element. The arabesque can be used to suggest the folds and shadows they produce with complete naturalness and without the need for a rigorous academic chiaroscuro treatment. The rhythm of the stroke in its comings and goings can be used to draw drapery, creating at the same time an attractive arabesque.

The folds can be as complicated as you want them to be. They can be constructed in an elongated, horizontal and vertical form, or (as you can see in this photograph) with creases that create an interesting texture from a pictorial point of view.

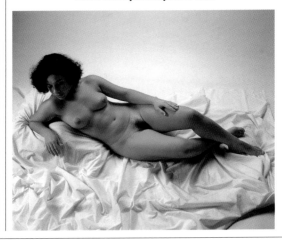

ATMOSPHERE

The atmosphere of a nude painting is created by the general color scheme, the harmony that predominates the scene and that evokes a specific type of lighting, a specific temperature and moment of the day. Atmosphere is a factor of artistic quality that deserves to be dealt with carefully.

Chromatic Atmosphere

Atmosphere must be present in the work as the air surrounding the figure. This is the opposite of the hardness and exactitude of the drawing. The atmosphere must be fluid, continuous, and unitary. Color can create an atmosphere so necessary for interpreting the nude in a wholly artistic sense. The combination of warm and cool tones, the quality of the flesh colors, the special sensation created by contrasts must all conform to a singular atmosphere. Some painters express this in terms of "the air that circulates around the work"; air also has its color, the atmospheric color that links the different colors of the objects together and merges into a single chromatic flow. Although this may seem difficult to

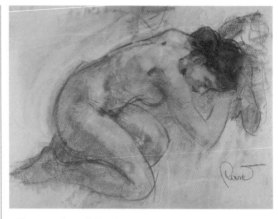

The atmosphere of this painting by Joan Raset is mainly produced by the difference between the color of the figure and the color of the paper.

represent, once the painting's color scheme has been correctly established (balanced, rich in contrasts and unitary), the atmosphere emerges on its own.

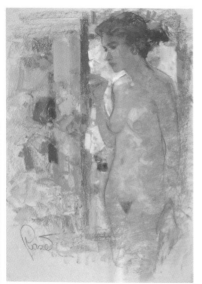

Another work by Joan Raset in which the high atmospheric quality stands out thanks to the contrast between an illuminated background and a figure painted almost in backlighting.

The Climate of the Work

The atmosphere always has a "temperature," its climate. The question of temperature was dealt with in the chapter on color ranges (warm, cool, and neutral color) in this book. The utilization and combination of ranges also creates a warm or cool climate. But climatic possibilities of the work are too diverse to include in a list of concepts: the possible number of shades is infinite and the combinations virtually impossible to repeat in any two works. This can be seen in the copies of paintings by the great masters: regardless of how faithful the copy may be, one can note there is something different, an imprecise and general quality that is not only in the drawing or in the color. This quality is the climate. The intensity and the quality of the light determine this climate but also condition the tones of

In this painting by Joan Raset, the atmosphere is warm and rich and abundant in color and the interplay of light.

the colors, chiaroscuro (or lack of it), the contrasts, the greater or lesser degree of modeling, and the utilization of flat colors or colors rich in hues.

General Harmony

Working within a color range (warm, cool, or neutral)—contrasting tones, adding tones from other ranges, intensifying, harmonizing, softening—the aim of all these actions is to achieve the general harmony of the work. When Cézanne was asked what his favorite color was, the great painter responded, "The general harmony." The general harmony is achieved when the painting has reached the stage in which all the colors support and accommodate one another, creating an organism without dissonance or monotony. In musical terms this stage could be compared to a chromatic chord, which contains multiple intonations but only one sound, a single harmony.

Ramon Sanvisens, Study of a Figure. Private collection. The chiaroscuro is always a factor in the creation of an illuminated atmosphere.

ABSTRACT COLOR

The artist must feel free to interpret the nude in a personal way, even if it means breaking with accepted conventions. One of the most extreme ways to interpret a nude is to use it as a pretext for an almost abstract color composition.

The Sense of Color

More than any other aspect of artistic creation, color is subject to imponderable circumstances and is impossible to classify in rules or norms. It is often the case that the intuition of the moment offers an unsuspected and unplanned color solution, which improves the work. When painting the nude an apparently pinkish flesh color painting may be expressed better with pale green, a color that is considered completely unsuitable. In moments like this—of true inspiration—the artist can disregard theories and rules, advice and previous aims, and rely purely on color instinct, on her personal sense of color. This sense is untransferable and is the exclusive domain of the individual artist. Some possess this to a greater extent and others to a lesser extent— there is not much that can be done in this respect. In any event, it is difficult to compare one colorist spirit with that of another: some people are colorists by abundance and others by the quality of the few colors and for the perfect harmonies they achieve.

The only advice is to allow yourself, when necessary, to be guided by instinct and enthusiasm.

Visual Intensity

The main aim of all painting is the purely visual attractiveness and intensity transmitted to the observer. This intensity may originate from pure color, as the inventors of abstract painting (the French artist Delaunay and the Russian Kandinsky) were so well aware of. Those pioneers discovered

Regardless of how abstract a work may be, the interpretation must always stem from a solid knowledge of the figure.

Anything goes for the artist (in this case Miquel Ferrón) as long as the approach to the nude is always based on sound principles of anatomical form.

that a painting can have a life of its own without the need to represent real objects, simply developing works to their max-

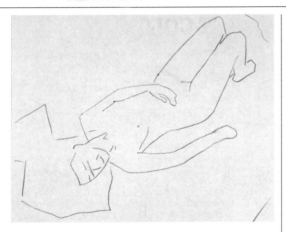

The free interpretation of color requires a relatively unelaborated line that leaves room for the imaginative elaboration of color.

Pure Colors

Pure colors have a visual intensity of their own that painters of nudes can exploit as long as they are ready to sacrifice the pure realism of the representation.

Working with contrasting color, combining warm and cool, light and dark tones is one of the artist's greatest assets today. In this circumstance, realism is relegated to a secondary status, although this does not mean artists can neglect the aspect of the composition, or those factors that relate to a well-proportioned figure.

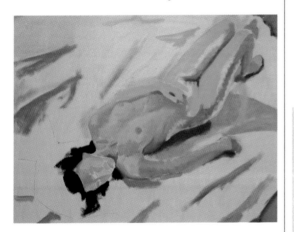

The freshness and simplicity of the colors of this figure do not conceal the general sketch lines that support it.

imum colorist possibilities. The lesson of those masters is applicable to our nude paintings, introducing beautiful colors to them without too much worry about the excessive intensity. This should not be carried out blindly and for no special reason; rather it should respond to a real inner necessity, to a personal impulse. The impulse cannot be feigned and when it is, it is at once identifiable. Technical knowledge is fundamental, constant practice is indispensable, and without one or the other there is no way to

achieve good results. But it is also important to remember that painting must be pleasure and never a boring routine. If the artist paints by inertia, it will appear evident in the painting; when a painting is executed with pleasure and enthusiasm, that pleasure and enthusiasm is conveyed to the spectator.

Painting is an art form, and as such, it has the virtue of being the exaltation of vitality.

The Quality of Light

The quality of light is directly responsible for the chromatism of the figure and its surroundings. There is no need to insist, as mentioned earlier, on the changes in color that skin undergoes according to the type of lighting it is placed under. Certain types of light, due to their intensity and coloration, annul the subtle hues of the skin and affect their tone. Natural light also determines certain chromatic variations: afternoon light, the warmest type, can lend a marvelous chromatism to the nude and accentuate the velvety quality of the skin. The artist can create in the studio different qualities of light by combining artificial lighting with natural lighting, by using fabrics as filters or screens, and by creating reflections, combining intensities, and so on.

Note: The titles that appear at the top of the
odd-numbered pages correspond to:

The previous chapter
The current chapter
The following chapter